IMAGES
of America

MOTOR CITY ROCK AND ROLL
THE 1960s AND 1970s

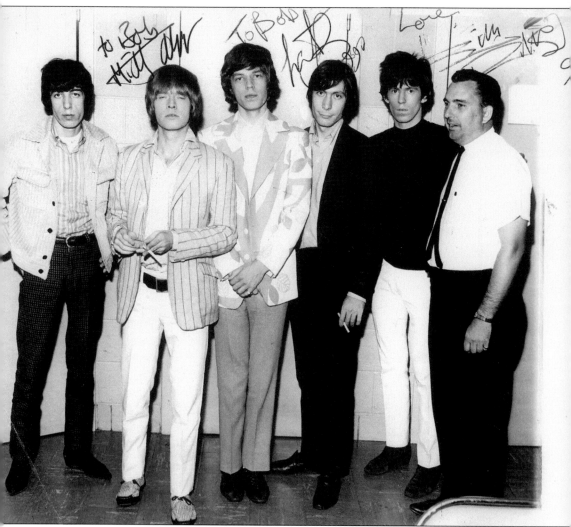

On June 12, 1965, the Rolling Stones released "(I Can't Get No) Satisfaction," their first No. 1 hit. The rest is history. The Rolling Stones came to Detroit to play Cobo Hall during their second tour of the United States, in November 1965. WKNR program director and disc jockey Paul Cannon called author Bob Harris, publisher of *Teen News*, and asked him to come down to see the Rolling Stones. Pictured here on November 4, 1965, are Bill Wyman, Brian Jones, Mick Jagger, Charlie Watts, Keith Richards, and Harris; 34 years later, in 1999, *Free Press* writer Dennis Niemiec brought Harris, whom Jagger had earlier dubbed the "Oldest Rolling Stones Fan in America," to meet with Jagger, Richards, and Watts so that they could sign his 1965 photograph. Between 1964 and 1998, the Rolling Stones released 57 top 100 hits. The Rolling Stones were inducted into the Rock and Roll Hall of Fame in 1989, and now, 43 years later, the Rolling Stones continue to tour, recognized as the greatest band in the history of rock and roll.

On the cover: Harris, a Detroit-based teen newspaper publisher, rock group manager, and concert promoter from the early 1960s through today is seen here with the Rolling Stones in 1965. Mick Jagger calls Harris the "Oldest Rolling Stones' Fan in America." (Bob Harris.)

IMAGES
of America

MOTOR CITY ROCK AND ROLL
THE 1960S AND 1970S

Bob Harris and John Douglas Peters

ARCADIA
PUBLISHING

Published by Arcadia Publishing
Charleston, South Carolina

Printed in the United States of America

Library of Congress Catalog Card Number: 2007943012

For all general information contact Arcadia Publishing at:
Telephone 843-853-2070
Fax 843-853-0044
E-mail sales@arcadiapublishing.com
For customer service and orders:
Toll-Free 1-888-313-2665

Visit us on the Internet at www.arcadiapublishing.com

This book is dedicated to the Motor City fans of 1960s and 1970s rock and roll. This book is also dedicated to the musicians, promoters, labels, studio musicians, engineers, songwriters, dancers, business people, stage hands, disc jockeys, and myriad others in the rock and roll world.

CONTENTS

ACKNOWLEDGMENTS

This book could not have happened without the help of many smart, talented, and dedicated people. Photographs were provided by Bob Harris, Frank Pettis, Leni Sinclair, Douglas Ashley, and Bob Alford. Photographs were also provided by members of the bands and fans of the bands and musicians pictured in this book. Especially helpful in identifying and providing Motown photographs was Lina Stephens, chief curator of the Motown Historical Museum. The authors are also grateful for the support of the Motown Historical Museum's executive director Robin Terry. Photographic reproductions were assisted by Douglas Digue and Sean Muciek. Paul Cannon, former program director with WKNR, and Keith Chinnery, program director of CKLW, provided archival photographs for which we are grateful. Generous assistance was also provided by Mark Bowden and Ashley Koebel from the Burton Collection of the Detroit Public Library. Final photographic production and restoration was done by master photographer Paul Cooney, photographic conservation specialist in imaging, at the Detroit Institute of Arts.

Thanks are extended to Tony Harris, for bringing the coauthors together; to Joyce White, a columnist from *Teen News*; and to the many musicians who still live in the Detroit area, who took time to share their stories and photographs with the authors. Thanks especially to Anna Wilson and John Pearson, our editors at Arcadia Publishing, for their commitment to quality.

Thanks are extended to AM stations, WCHB, CKWW, WPON, and FM stations, Oldies 104.3, WCSX, WDRO, WIOT (Toledo), and CKLW (Windsor), for their continuing broadcasts of classic rock and roll. Thanks are also extended to XM satellite radio for its national broadcasts.

Finally the authors extend their thanks to the law firm of Charfoos and Christensen, P.C., one of Detroit's oldest litigation firms. This law firm also contributed through its staff, including attorney David Parker and employees Dennis Kot, Mary Jane Tytran, Rod Hairston, and Claudia French, who did typing and research for the manuscript. Special thanks are extended to Catherine Kulchyski, whose extensive efforts at typing, materials organization, research, and proofreading were invaluable in the completion of the book.

INTRODUCTION

This rock-and-roll picture book presents over 200 historic pictures of local, national, and international rock-and-roll musicians and bands heard or seen by Motor City rock fans in the 1960s and 1970s. Many believe these two decades saw "the Golden Age of Rock and Roll." The musicians, bands, personal stories, and ephemera are presented in rough chronological order to give the reader a sequential flash-forward.

Radio disc jockeys, television "teen dance" show hosts, and rock newspapers such as *Teen News* spread the rock word to a cool generation. In the late 1950s and early 1960s, rock was controversial. Irate parents and businesses would often pressure the men and women who tried to bring rock to the new audience. Some disc jockeys lost their jobs when stations buckled under pressure. Some musicians were investigated by the FBI as possible subversives. Some were arrested. Photographs of these rock apostles are included in this book.

In spite of casting a wide net in search of material, some local and national bands are omitted here, not because of personal taste or politics, but due to an inability to find a telling image. And in spite of careful fact checking, it is amazing how sources give conflicting information regarding spellings, dates of birth, causes of death, and so forth. We regret any error, but rock history is untidy.

Because of the potential for endless debate about what is rock, and which musicians and bands should be "in" or "out," this book defines rock broadly. A definition of *rock* sounds simple: electric guitars, miked drum kits, the beat, and so on. Using this yardstick, exceptions appear. Is it rock when Paul McCartney sings a ballad? There is soft rock, hard rock, surf rock, acid rock, punk rock, pop rock, Goth rock, folk rock, country rock, Christian rock, and so on; rock and roll become the massive middle of a fused bell curve.

Unless otherwise attributed, photographs in this book are from the archives of author Bob Harris, a Detroit-based teen newspaper publisher, rock group manager, and concert promoter from the early 1960s through today. Mick Jagger calls Harris the "Oldest Rolling Stones Fan in America." Their 1965 photograph together (on the cover) attests to the quality of Harris's archive.

The role of technology in the creation and spread of rock and roll is not addressed in this book. Nor does this book address the political issues that fueled two decades of generational war. Rock escalated and amplified the speech of generations. On the less serious side, much of rock and roll is about boys and girls, cars, love, life, and just plain fun.

Must-see rock museums include the Motown Historical Museum in Detroit and the Rock and Roll Hall of Fame in Cleveland.

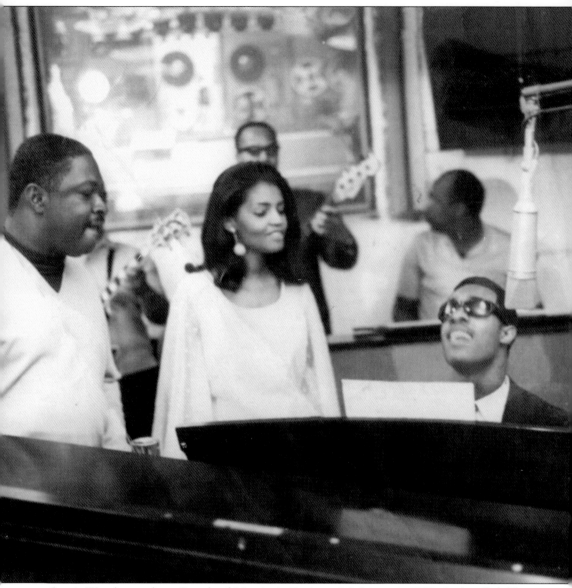

Stevie Wonder was born Steveland Morris, in Saginaw, Michigan, in 1950. Author Bob Harris, was producing entertainment for the Michigan State Fair in the early 1960s when one of his staff came to him to say, "All the crowds are gone, and there's a little kid up on the stage with a microphone and he won't stop singing." Harris approached the boy to find that he was blind and could not find the brother he came with. Little Stevie asked for a ride to the bus, but Harris and his wife drove the not-yet-famous singer home. Stevie's first top 100 hit, "Fingertips-Pt 2," went to No. 1 and stayed on the 1961 charts for an incredible 15 weeks. Here Stevie plays in Motown's famous Studio-A as songwriter Sylvia Moy looks on. Motown writer and producer Hank Cosby stands at left. Robert White stands behind Moy, and Earl Vandyke plays keyboards. Session players in the background suggest that this photograph captures a rehearsal of one of the songs Moy wrote for Stevie.

One

ROCK'S ROOTS

William Henry
"Chick" Webb, born in
Baltimore, first played
professionally at age 11.
He was deformed by
spinal tuberculosis, but
at age 17, he moved to
New York City to form
his own band. Webb
and Gene Krupa are
credited with building
the first drum kits.
In 1931, Webb's act
became the house band
at the Savoy Ballroom.
Drumming legend
Buddie Rich referred
to Webb as the "daddy
of them all." When
a battle of the bands
competition brought
Webb's band against
the Benny Goodman
Orchestra, featuring
drummer Gene Krupa,
Goodman's band left
drained and defeated.
Webb died in 1939.

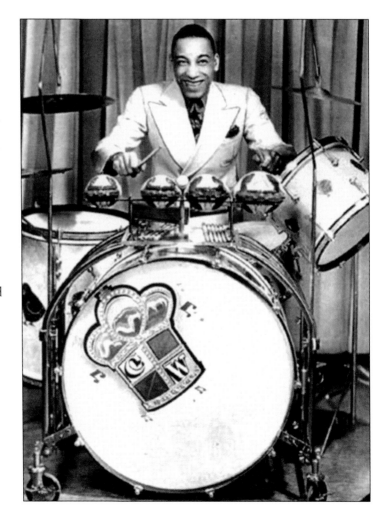

Charles Henry (Charlie) Christian was born in Bonham, Texas, in 1916. One of the first musicians to experiment with an electrically amplified guitar, Christian was discovered in 1939 by music critic and talent scout John Hammond. Hammond pressed Benny Goodman to give Christian a spot in his band. Until then, guitars had not had a role in bands because they were overpowered by the other instruments. In 1939, Charlie Christian and the Benny Goodman Band played the Michigan State Fair in Detroit. He died in 1942.

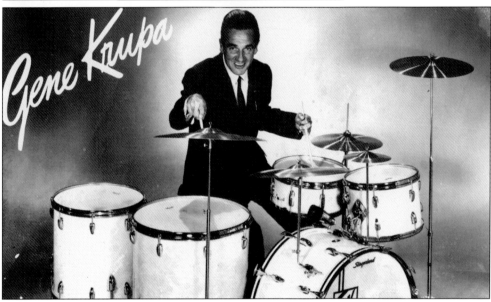

Gene Krupa is a father of the drum solo and the modern kit. Born in Chicago in 1909, he convinced the Slingerland Drum Company to make tunable tom-toms, and he worked with the Zildjian Cymbal Company to develop today's hi-hat cymbals. Krupa was the first drummer to record with a bass drum, and on January 16, 1938, his band was the first to play jazz in New York City's Carnegie Hall. While playing in Detroit, Krupa gave instruction to the young drummer in one of coauthor Bob Harris's rock groups. He died in 1973.

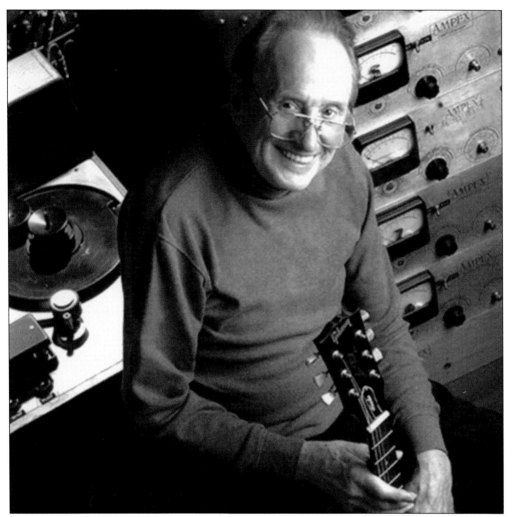

Les Paul was born Lester William Polfuss, in Waukesha, Wisconsin, in 1915. A significant developer of modern electrical instruments and recording techniques, to most fans, Paul is known for his guitar performances with his former wife, Mary Ford. This 1970s photograph captures the brilliant innovator along with some of his inventions. In 1941, Paul designed and built one of the first solid-body electric guitars. In the early 1950s, Gibson Guitar Corporation designed a guitar incorporating Paul's designs. The Gibson Les Paul model is still a favorite of Detroit guitarists, amateurs, and professionals alike. In 1947, Paul made a recording of himself playing eight different parts—this was the first time multi-tracking was used. In 1954, Paul designed "Sel-Sync," a recording technology for multi-track recording used through the mid-1980s. Les and Mary were inducted into the Grammy Hall of Fame in 1978, and in 1988, Paul was inducted into the Rock and Roll Hall of Fame. In 2006, at the age of 90, Paul won two Grammys for his album *Les Paul and Friends*.

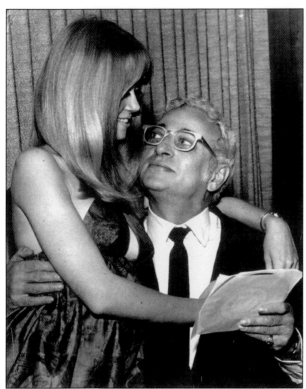

John Kaplan, trained as a certified public accountant, returned to Detroit from the service in 1946. With no background in the music business, Kaplan bought a record distributorship for $13,000, and overnight he and his partner became the first independent record distributors in Michigan. Kaplan and famed disc jockey Ed McKenzie became friends, which helped Kaplan move his labels into record stores. Barney Ales, of Motown promotion fame, trained under Kaplan. Professional photographer Douglas Ashley captured Kaplan on film in the mid-1960s. (Frank Pettis.)

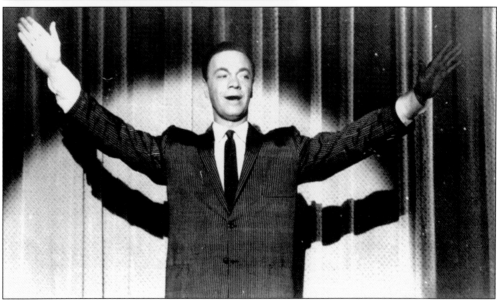

Alan Freed, a disc jockey and promoter from Cleveland, brought his troupe to Detroit on many occasions and is credited with putting together the first rock-and-roll stage show, the Moondog Coronation Ball, in the Cleveland Arena, on March 21, 1952. Freed is also credited with coining the phrase "rock and roll." His "Moondog" howls inspired Wolfman Jack's persona. Freed, who died in 1965, was inducted into the Rock and Roll Hall of Fame, in its first class, in 1986. (Frank Pettis.)

As Alan Freed tried to promote a new music form, others resisted. In the mid-1950s, the U.S. Congress held hearings on rock and roll. Congressman Emanuel Celler said that rock and roll is "animal gyrations" and that it "caters to bad taste." Freed was a visionary, a promoter, and an American businessman. In this 1958 poster, a who's who of rock and roll, promoted by the great Freed, note that "This Show Will Not Appear in Detroit—only Windsor." (Frank Pettis.)

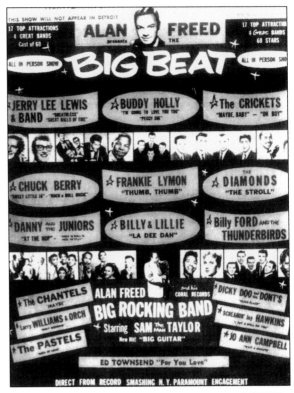

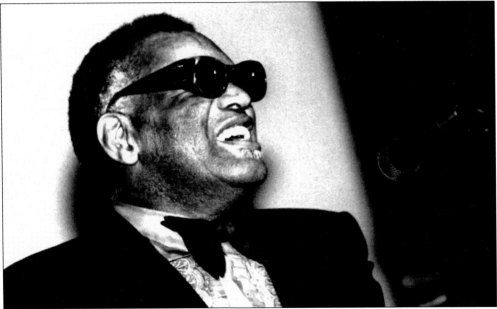

Born in Albany, Georgia, in 1930, glaucoma completely blinded Ray Charles Robinson by age five. Robinson studied classical piano and clarinet at the State School for Deaf and Blind Children, in St. Augustine, Florida. His first No. 1 hit, "Georgia on My Mind," was released in 1960. Ray received Grammy's Lifetime Achievement Award in 1987. Ray Charles, whose concerts in Detroit always sold out, died in 2007 at 77 years. (Leni Sinclair.)

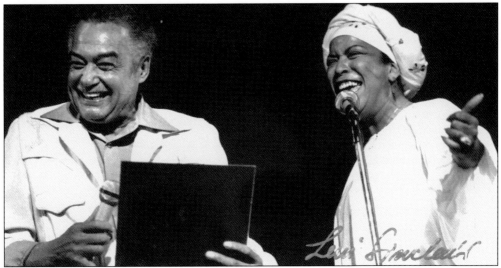

Della Reese was born Delloreese Patricia Early in Detroit in 1931. Reese sang with the Mahalia Jackson gospel troupe and with Erskine Hawkins. Since 1957, Reese has sung solo and her biggest hit, "Don't You Know," was released in 1959. Over her career, Reese has had 10 top 100 hits. She appeared in the 1958 movie *Let's Rock* and the 1989 movie *Harlem Nights*. In this 1976 photograph, Reese and Detroit's mayor Coleman Young share a microphone at the Masonic temple. (Leni Sinclair.)

George Young was born in Detroit in 1936. While attending Cass Tech High School in the early 1950s, Young began to sing and play guitar professionally; at 18, he appeared with Bobby Darin. Young was the opening act at Pier 500 in Wyandotte for 20 years. During his army years, Young was stationed in Freiburg, Germany, where he became friends and jammed with another soldier/musician: this photograph of Young and Elvis Presley was taken in Bad Nauheim, Germany, in the late 1950s. (George Young.)

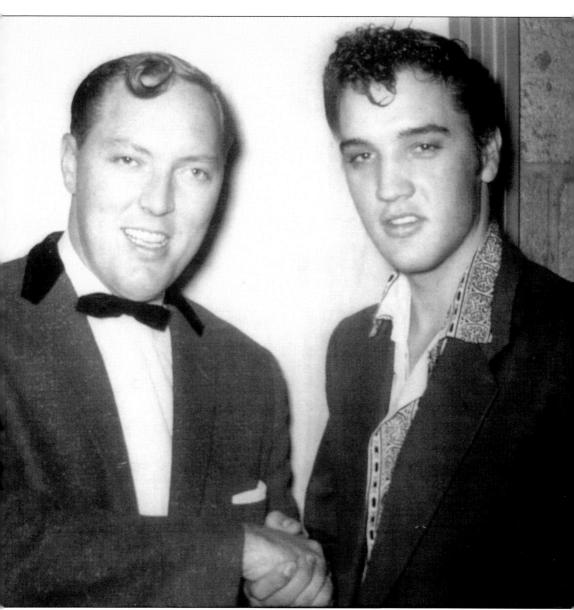

Bill Haley, born in Highland Park, Michigan, in 1925, meets Elvis in this 1955 photograph. Bill Haley and His Comets released "Shake, Rattle and Roll" in August 1954. Elvis did not have his first top 100 hit until 1956. Both men became rock icons. Haley's hair curl, as seen here, was intended to disguise his blind left eye. Haley had 28 top 100 hits and died in 1981, at 55. Elvis was born in 1935 and died in 1977, at 47 years. Over his career, Elvis Presley, the undisputed "King of Rock and Roll," had 153 top 100 hits. By comparison, the Beatles had 73 top 100 hits. This photograph best represents the focus of this book, the melding of Michigan, national, and international talent that turned on the rock and roll for Motor City fans in the 1960s and 1970s. (Frank Pettis.)

School Days
1957 '58

Art Azzaro moved to Waterford, Michigan, a Detroit suburb, in 1979. In 1958, 21 years earlier, when Azzaro was 14, he hopped onto his Lambretta scooter and rode to the Connie Mack Stadium, in West Palm Beach, Florida. With his Brownie box camera, young Azzaro captured three legends of rock and roll. Azzaro recalls, "There may have been 1,000 people there that day, in the spring of 1958." Azzaro, still a camera buff, is pictured above, now and then. (Art Azzaro.)

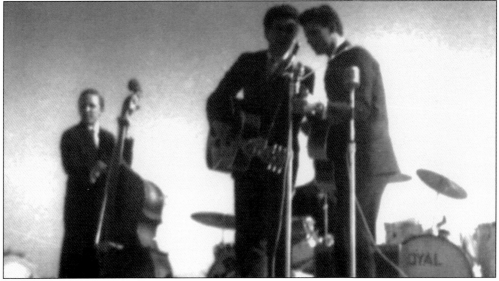

The Everly Brothers first played Detroit in 1957 at the Fox Theater. They frequently toured with Bill Haley and the Comets, Buddy Holly, and the Royal Teens. When these groups performed at this 1958 concert, the Everly Brothers were captured by 14-year-old Azzaro's Brownie camera. These musicians used each other's equipment. Notice the acoustic standup bass player. In two years, acoustic instruments would be on the way out. Saxophones also started to fade from use in the early 1960s.

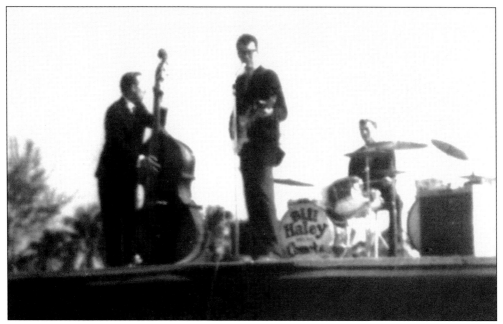

Buddy Holly's trademark black horn-rimmed glasses indicate who he is. When 14-year-old Azzaro took this 1958 photograph, his box camera technology prevented sharpness at this distance. The drummer and bass player are most likely members of Bill Haley and the Comets. Holly first played Detroit in 1957 with the Everly Brothers.

In 1953, Bill Haley and the Comets "Crazy Man, Crazy" was the first rock and roll hit to make the pop charts. In 1954, "Shake, Rattle and Roll" ushered in the age of rock and roll. Appearing in Glenn Ford's 1955 film *Blackboard Jungle*, "Rock Around the Clock" went right to No. 1. Over his career, Haley scored 27 top 100 hits and was inducted into the Rock and Roll Hall of Fame in 1987. Bill Haley, born in the Detroit suburb of Highland Park, died in 1981 at 55 years.

Television and radio personality Robin Seymour has the microphone in this 1965 picture. To Seymour's right are Bill Kurth, of Meyers Music Store; Bob Adamski, singer for the Invictas; and the owner of Mushrow's Music Store, Vick Mushrow. Seymour's "Swingin' Time" ran on CKLW-TV through 1968. Six days a week, 50 to 75 teens danced on his record-making or record-breaking show—during each show, two teens gave a "yea" or "boo" to new releases. Seymour still writes and produces in California.

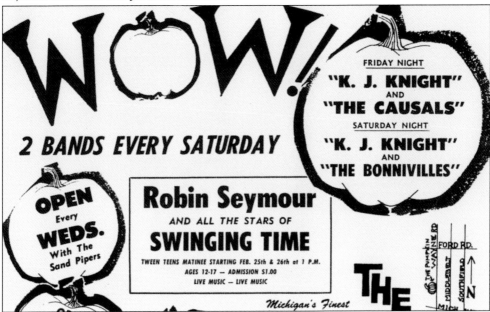

Clubs like the Pumpkin and media personalities such as Seymour worked together to promote rock and roll. Clubs catered to teen demand, which producers like Seymour created. Recognized as Disc Jockey of the Year in 1953 by *Billboard*, none could challenge Seymour's position or star power. From the time of big bands through the British invasion, Seymour was a key apostle. This advertisement appeared in a 1965 issue of Detroit's *Teen Times*.

Chuck Berry was born Charles Edward Anderson Berry, in St. Louis, in 1926. He is a living and still performing legend of rock and roll at 82 years. Considered one of rock and roll's most important influences, his first hit, "Maybelline," became an instant classic when it was released on the Chess label in 1955. In 1957–1958, he recorded "Rock Roll Music," "Sweet Little Sixteen," and "Johnny B. Goode." In 1984, Berry received Grammy's Lifetime Achievement Award, and in 1986, he was in the first class inducted into the Rock and Roll Hall of Fame. He frequently plays Detroit with his old friend Jerry Lee Lewis. (Frank Pettis.)

Pat Boone was born Charles Eugene Boone in Jacksonville, Florida, in 1934. In 1954, he won an Arthur Godfrey Talent Scout Competition that launched his career. His second top 100 hit, "Ain't That a Shame," went to No. 1 in 1955. By 1964, Boone had recorded 58 of his 60 top 100 hits. His career dropped in 1964, in part due to the edgier British invasion bands and a more leftward social shift in America. Detroit "radical" John Sinclair declared, "Pat Boone NEVER made a good record." Boone appeared in 15 movies and is proud of being married for 54 years, as of 2008. (Frank Pettis.)

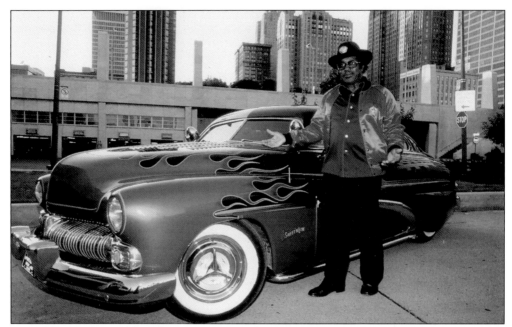

Bo Diddley was born Otha Ellas Bates McDaniel in 1928 in McComb, Mississippi, but was raised in Chicago. This master guitarist and singer got his nickname from a one-stringed African guitar called a bo-diddley. He recorded five top 100 hits and was inducted into the Rock and Roll Hall of Fame in 1987. He received Grammy's Lifetime Achievement Award in 1998. In this photograph (Detroit's Guardian Building, upper right), Diddley stands beside his black, blue-flame painted 1949 Mercury. (Robert Alford.)

The Royal Jokers came together in Detroit, in 1952, and included Norman Thrasher (bass), Noah Howell (tenor), Thearon "T-Man" Hill (lead tenor), and Isaac (Ike) Reese (baritone-bass). Their name, the Royal Jokers, was suggested by Maurice King, the bandleader at the Flame Show Bar, because their act had humor. In 1955, they had their one top hit, "You Tickle Me Baby," released on the Atco label. In this 1960s photograph, they are playing a local club.

The Platters formed in Los Angeles in 1954. The original members were Tony Williams (1928), lead singer; David Lynch (1929), tenor; Paul Robi (1931), baritone; Herb Reed (1928), bass; and Zola Taylor, vocalist, known as "the Dish of the Platters." Their first top 100 hit, "Only You (And You Alone)," was originally recorded on the Federal label, and in 1955, it was rerecorded and released on the Mercury label. The Platters are widely recognized as rock and roll royalty. By 1967, they had 40 top 100 hits. The group was inducted into the Rock and Roll Hall of Fame in 1990. (Frank Pettis.)

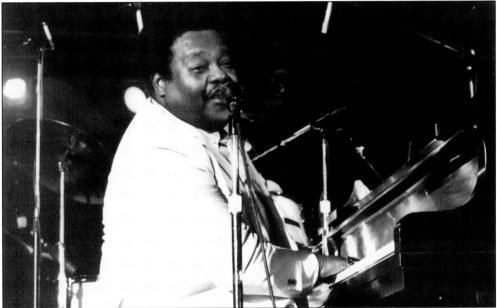

Fats Domino was born Antoine Domino, in New Orleans in 1928. His first top 100 hit, "Ain't It a Shame," was released in 1955. Domino recorded one of his first hits, "Detroit City Blues," in 1950. He recorded 66 top 100 hits between 1955 and 1968. He appeared in the movies *Shake, Rattle and Rock!* and *The Big Beat*. He received Grammy's Lifetime Achievement Award in 1987. (Frank Pettis.)

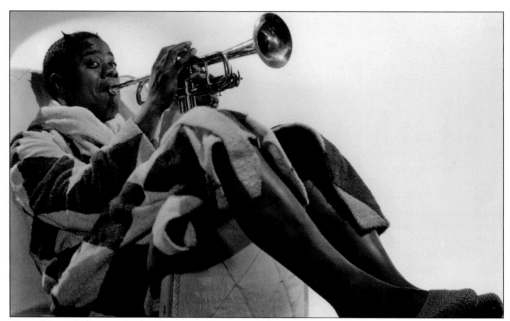

Daniel Louis Armstrong was born in New Orleans in 1901. Nicknamed Satchmo, he joined the big-time band of Joe "King" Oliver, in Chicago in 1922. By 1929, Louis Armstrong was one of the best-known musicians in America. In 1930, he performed in Detroit under manager Tommy Rockwell. In 1956, "A Theme from the Three Penny Opera (Mack the Knife)," became his first top 100 hit. In 1972, Armstrong won Grammy's Lifetime Achievement Award. He died in 1971, at 69 years, and was inducted into the Rock and Roll Hall of Fame in 1990.

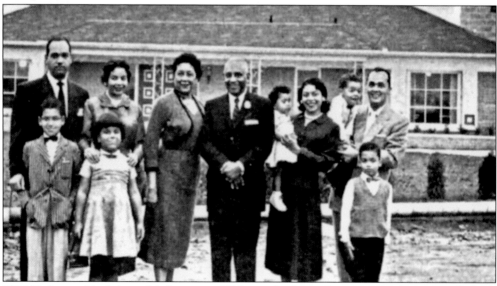

WCHB, licensed in Inkster, Michigan, in 1956, was the first radio station in America to be built from the ground up by African Americans. The call letters came from the first letters of the names of the two founders, Dr. Wendell Cox and Dr. Haley Bell. In this early family photograph, Cox and his family stand with Bell and his wife. They started an FM sister station (WCHD, which became WJZZ) in 1960. In 1998, Bell Broadcasting sold its stations to Radio One. Cox died in 2007. (Cox family.)

Peggy Lee was born Norma Jean Egstrom in Jamestown, North Dakota, in 1920. This very talented lady first sang as a jazz singer with Jack Wardlow's band between 1936 and 1940. She sang with the Benny Goodman Orchestra between 1941 and 1943. Her first top 100 hit, "Mr. Wonderful," was released on the Decca label in 1956. In 1958, she recorded "Fever," and everybody caught it. Between 1956 and 1969, she had 11 top 100 hits. She mentored Madonna, Michigan's own. (Frank Pettis.)

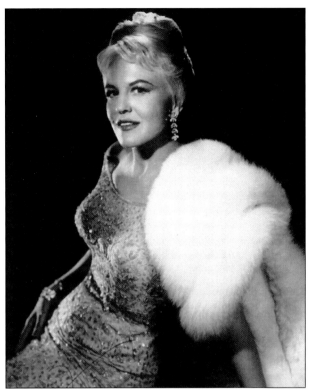

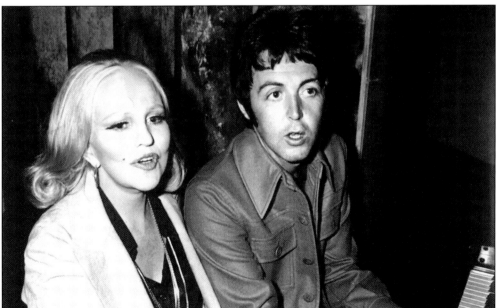

Lee, by now a matriarch of rock-vocal music, works with a young English songwriter and guitarist in this 1974 photograph. To see the sharing of music and ideas that pass through generations, as this picture shows, is part of the torch passing role that great musicians play. When Elvis came home from the Army, Frank Sinatra threw a welcome home party that told the adult world that Elvis was okay. In 1995, Peggy Lee won Grammy's Lifetime Achievement Award.

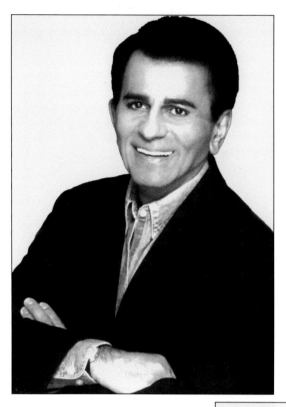

Kemal Amin "Casey" Kasem, born in Detroit in 1932, started his radio career at Detroit station WJBK in the mid-1950s. He became a world famous disc jockey, producer, and historian of rock and roll. He founded the American Top 40 franchise in 1970 and was heard all over the world between 1970 and 2004. A graduate of Wayne State University, he was inducted into the Radio Hall of Fame in 1992. Kasem and his wife, Jean, live in California, where they are active in businesses and politics. (Frank Pettis.)

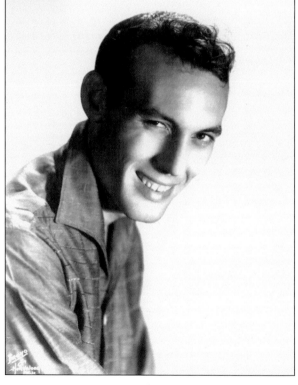

Carl Perkins, Sun label stablemate of Elvis, Johnny Cash, and Jerry Lee Lewis, was born in Tiptonville, Tennessee, in 1932. His first top 100 hit, "Blue Suede Shoes," was released on the Sun label in 1956. Although he had four lesser top 100 hits, his career was crushed when his car crashed on a trip to New York for a television appearance. He later became a member of Cash's touring troupe. Perkins's album of dance songs was recorded at Detroit's Getto Studio. In 1998, he died at 65 years. (Photograph by Bruno of Hollywood, courtesy of Frank Pettis.)

Johnny Cash was born in Kingsland, Arkansas, in 1932. As a teen, he moved to Detroit and later worked on the Cadillac assembly line in Detroit. After serving in the U.S. Air Force between 1950 and 1954, he formed a trio with Luther Perkins (guitar) and Marshall Chapman (bass). He first recorded on the Sun label in 1955 and had 48 top 100 hits. In 1968, he married June Carter. He was inducted into the Rock and Roll Hall of Fame in 1992. Cash died in 2003, at 71 years, less than four months after the death of his wife. (Frank Pettis.)

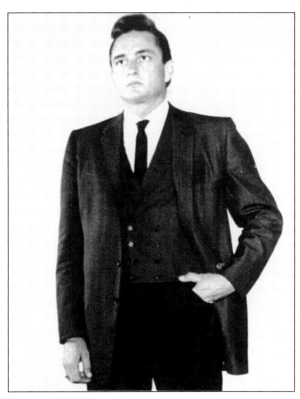

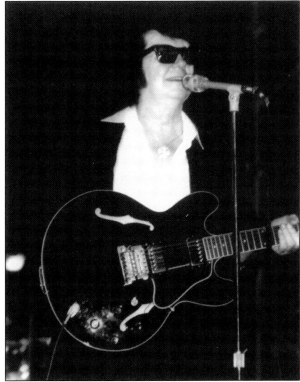

Roy Orbison, of the soaring high-tenor voice, was born in Vernon, Texas, in 1936. His first top 100 hit, "Ooby Dooby," was released on the Sun label in 1956. In 1961, he had his first No. 1 hit, "Running Scared." He recorded "Crying" the same year. In 1963, at their request, he toured with the Beatles. In 1964, "Oh, Pretty Woman," became his last No. 1 hit. Orbison and friends recorded an album used to raise funds for Detroit's Public Television. He died of a heart attack at 52 years. In 1998, he won Grammy's Lifetime Achievement Award. (Frank Pettis.)

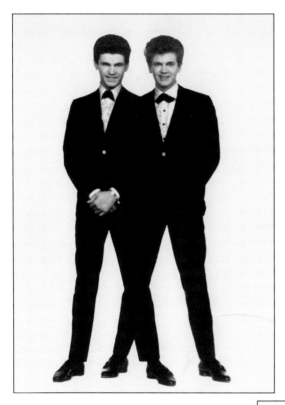

The Everly Brothers, Isaac Donald (1937) and Philip (1939), began singing as a duo before they were 10. Their parents, folk and country singers, included the boys in their act. After high school, Chet Atkins invited the boys to Nashville where they first recorded on the Columbia label in 1955. "Bye Bye Love" was their first top 100 hit. Their biggest hits, "Wake Up Little Susie," "All I Have to Do Is Dream," "Cathy's Clown," and "(Til) I Kissed You," were all released by 1960. Between 1957 and 1984, they had 38 top 100 hits.

Jackie Wilson was born in Detroit in 1934. Like Berry Gordy, who admits Wilson was an inspiration, Wilson was an amateur boxer. He sang solo until 1953, when he joined Billy Ward and His Dominoes. He returned to solo in 1957. His first top 100 hit, "Reet Petite (The Finest Girl You Ever Want to Meet)," was released in 1957. His monster hit "Lonely Teardrops" was released in 1958. He recorded 54 top 100 hits. He died in 1984, at 49 years and was inducted into the Rock and Roll Hall of Fame, in the second class, in 1987. (Frank Pettis.)

Brenda Lee was born Brenda Mae Tarpley, in Atlanta in 1944. Dubbed "Little Miss Dynamite," Lee began singing professionally at age six and signed with Decca in 1956. Her first top 100 hit was released in 1957. Her first big hit, "Sweet Nothin's," had a sexy-rocky edge. In 1960, Lee had two No. 1 hits, "I'm Sorry" and "I Want to Be Wanted." This same year, Lee played the Michigan State Fair in Detroit. Her 1962 release, "Rocking Around the Christmas Tree," sold over seven million copies. Lee recorded 55 top 100 hits and was inducted into the Rock and Roll Hall of Fame in 2002. (Frank Pettis.)

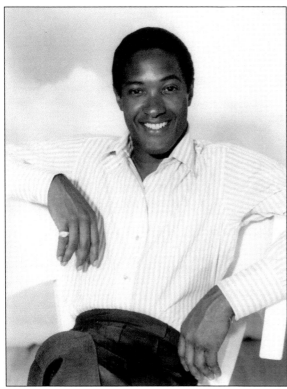

Sam Cooke was born in Clarksdale, Mississippi, in 1931, with a pure sweet voice. The son of a Baptist minister, Cooke sang in the choir from the age of six. His first top 100 hit, "You Send Me," went to No. 1. In 1964, he addressed civil rights issues in his hit "Change Is Going to Come." He wrote this song in response to Bob Dylan's "Blowin' in the Wind." He sang at Aretha Franklin's father's church in Detroit when Franklin was 10. Cooke had 43 top 100 hits. He was killed by a female motel manager under mysterious circumstances in 1964. (Frank Pettis.)

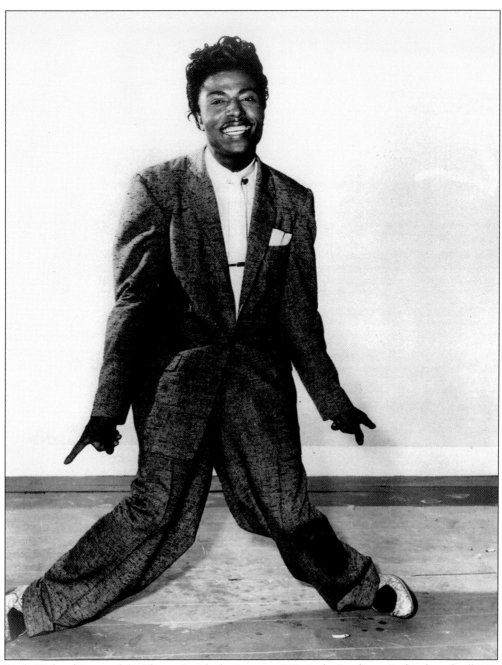

Little Richard is one of the "firstest" with the "mostest." He is the "architect" of rock and roll. His moves, his energy, and his enthusiasm are unique. Born Richard Wayne Penniman, in Macon, Georgia, in 1932, he first recorded with RCA in 1951. Between 1953 and 1955, he performed with the Temp Toppers. As a rock icon, he performed in early rock-and-roll movies such as *Don't Rock the Rock* and *Mister Rock 'n' Roll*.

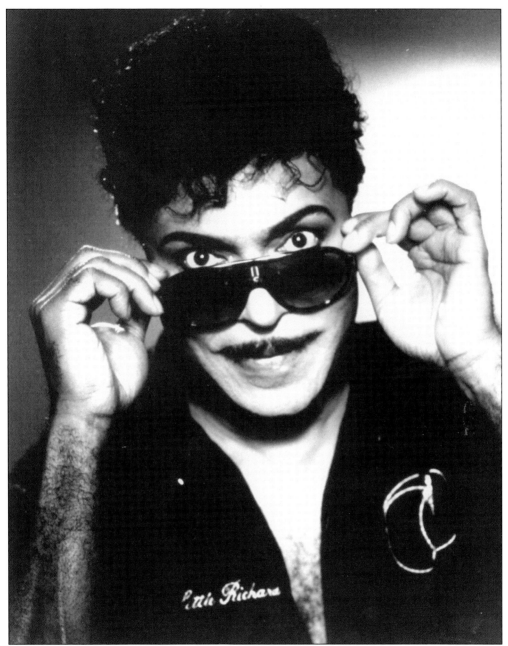

Little Richard's first top 100 hit, "Tutti-Frutti," was released on the Specialty label in 1956. "Long Tall Sally" was released the same year. "Good Golly, Miss Molly" followed in 1958. In 1986, Little Richard was in the first class inducted into the Rock and Roll Hall of Fame, and in 1993, he received Grammy's Lifetime Achievement Award. Between 1956 and 1986, he notched 21 top 100 hits. Little Richard performed to a sell-out audience at the Michigan Theater in 2007.

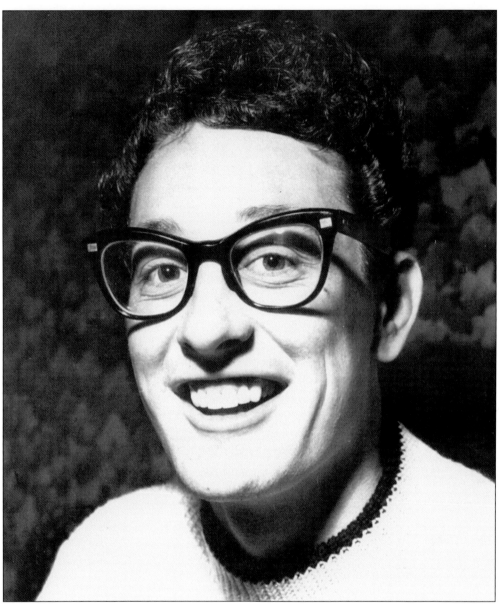

Buddy Holly was born Charles Harden Holley in Lubbock, Texas, in 1936. He and his friend Bob Montgomery began recording demos in 1954. An Elvis concert in 1955 inspired a change in their music. Leaving the South and his friend Montgomery behind, he signed with the Decca label in New York in 1956. From there, he moved to the Brunswick and Coral labels. His first top 100 hit, "That'll Be the Day," went to No. 1 and stayed there for 22 weeks in 1957. "Peggy Sue" came out the same year. When Holly played in Liverpool, England, in March 1958, young John Lennon and Paul McCartney were in the audience. Holly split from the Crickets in 1958. In 1959, during a successful "Winter Dance Party" tour, to avoid using their unreliable bus, Holly, Ritchie Valens, and the Big Bopper took a small plane instead. It crashed near Mason City, Iowa, on February 3, 1959, killing all on board. In Don McClean's song, this "was the day the music died." Holly was in the first class inducted into the Rock and Roll Hall of Fame in 1986. (Frank Pettis.)

Jack Scott was born Jack Scafone Jr., in Windsor, Ontario, Canada, in 1936. This singer, songwriter, and guitarist moved to Hazel Park, Michigan, in 1946. His first top 100 hit, "My True Love," was released in 1958. In 1960, he released "Burning Bridges," his second big hit. Scott had 19 top 100 hits. Always a Motor City favorite, today Scott lives in Sterling Heights, Michigan, and still plays across America and tours in Europe. (Photograph by James J. Kriegsmann, courtesy of Frank Pettis.)

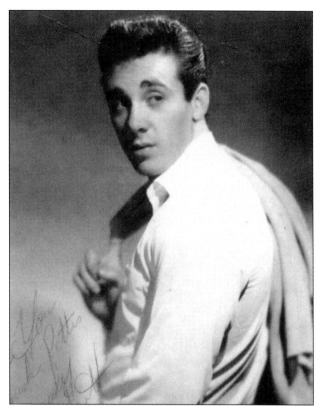

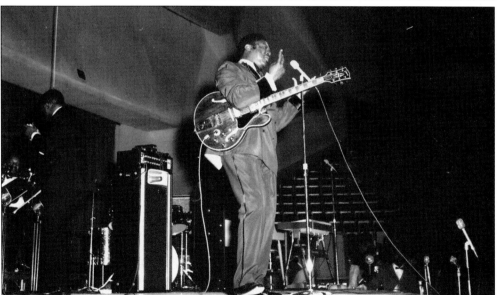

B. B. King was born Riley B. King in Itta Bena, Mississippi, in 1925. At 24, he had his own radio show on WDIA (Memphis). He was called the "Beale Street Blues Boy," later shortened to "Blues Boy," and ultimately, "B. B." His biggest hit, "The Thrill Is Gone," was released in December 1969. King had 36 top 100 hits. In this photograph, King is playing at Cobo Hall in Detroit in the early 1970s.

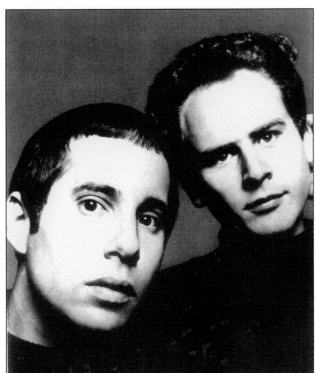

Paul Simon (1941) and Art Garfunkel (1941) formed a folk-rock duo in New York City. In 1957, they recorded their first top 100 hit, "Hey, Schoolgirl," under their original duo name, Tom and Jerry. Splitting up in 1964, Simon worked solo in England, and Garfunkel went to graduate school. Together again in 1965, they had their first No. 1 top 100 hit, "The Sounds of Silence." They reunited for a tour in 1981, and in 2003, they reunited to perform at the Palace in Auburn Hills, Michigan. They were inducted into the Rock and Roll Hall of Fame in 1990.

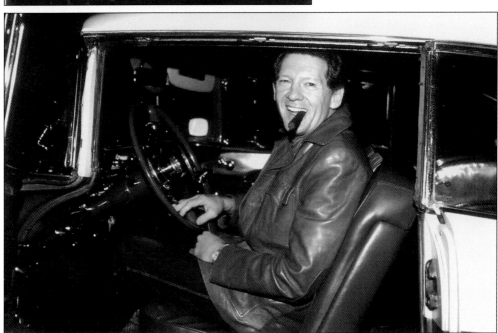

Jerry Lee Lewis, also known as "the Killer," enjoys a big cigar as he sits in his two-toned 1955 Pontiac Star Chief, in the Cobo Hall parking lot. Born in Ferreday, Louisiana, this rock pioneer recorded his first top 100 hit, "Whole Lot of Shakin' Going On," in 1957 on the Sun label. "Great Balls of Fire" followed that same year. Lewis has recorded 18 top 100 hits. He continues to perform, often with his old friend, Chuck Berry. (Robert Alford.)

The Lettermen was formed by, Tony Butala (1938), Jim Pike (1936), and Bob Engemann (1936) in Los Angeles in 1958. Engemann was born in the Detroit suburb of Highland Park in 1936. Picked by *Billboard* as the No. 1 Adult Contemporary Vocal group of the 1960s, this group had 20 top 100 hits between 1961 and 1971. "When I Fall in Love," and "Goin' Out of My Head Can't Take Eyes off You," are some of their biggest hits. Their last recording was "Love" (1971), written by John Lennon. Butala still performs with a "Lettermen" touring group.

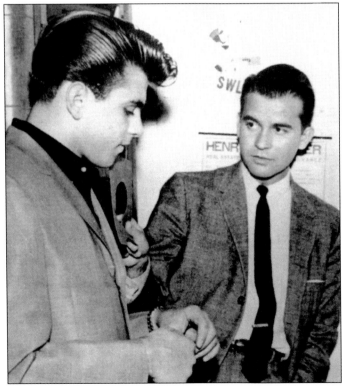

Dick Clark holds an empty 45 jacket in his right hand as he talks with a young Fabian. Born Richard Wagstaff in 1929, Clark became a rock-and-roll kingmaker as host of the nationally televised *American Bandstand*, first broadcast in 1957. Known as "America's Oldest Teenager," Clark also ushers in the New Year with his nationally televised *Dick Clark's New Year's Rockin' Eve*. In 1973, Clark created the American Music Awards. (Frank Pettis.)

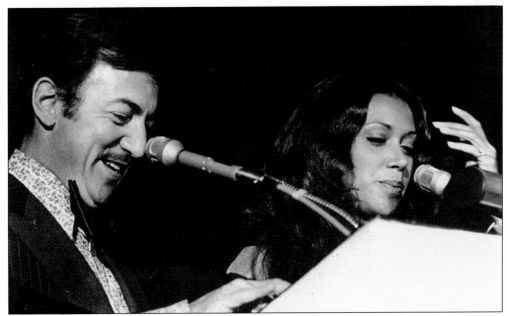

Bobby Darin was born Walden Robert Cassotto in the Bronx, New York City, in 1936. In 1956, he made a big television appearance on *The Tommy Dorsey Show*. After winning the Best New Artist Grammy Award in 1959, he married America's sweetheart, Sandra Dee, in 1960. Darin's biggest hit was "Mack the Knife." He recorded 41 top 100 hits. In this early 1970s photograph, Darin and actress Denise Nichols share masters of ceremony duties in Detroit. He died at 37 years in 1973.

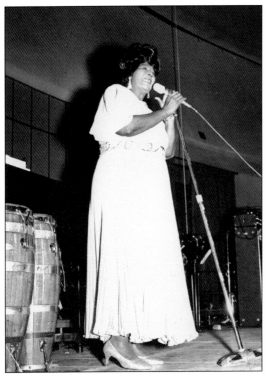

Mahalia Jackson was born in New Orleans in 1911. Greater and more important to the early rock genre than her number of hit recordings suggest, she began recording in the mid-1940s. This was about a decade before top 100 hits were first tabulated. One of the world's most famous gospel singers, Jackson's first top 100 hit, "He's Got the Whole World in His Hands," was released on the Columbia label, in 1958. She died at 60 years, in 1972. This mid-1960s Cobo Hall performance photograph is from the collection of Bob Harris. She was inducted into the Rock and Roll Hall of Fame, as an early influence, in 1997.

Frankie Avalon was born Francis Avellone, in Philadelphia in 1939. In 1956, he sang and played trumpet with Bobby Rydell in his band, Rocco and His Saints. His first top 100 hit came in 1958. In 1959, his first No. 1 hit, "Venus," made him a star. "Why," his second No. 1 hit, was released the same year. Between 1958 and 1962, Avalon had 24 top 100 hits. He was Annette Funicello's love interest in movies and also appeared in *The Alamo* with John Wayne. In 2003, he performed in a production of *Grease* at Western Michigan University. (Frank Pettis.)

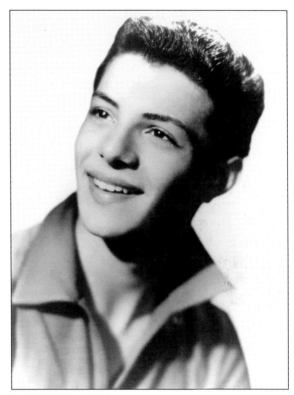

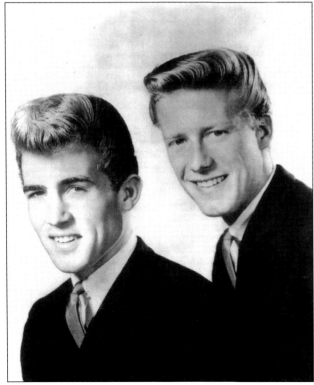

Jan and Dean, Jan Berry (1941) and Dean Torrence (1940), formed their influential surf-rock duo in Los Angeles in 1958. Although the duo had its first top 100 hit, "Baby Talk," on the Dore label in 1959, their first No. 1 hit was not released until 1963. "Dead Man's Curve" and "The Little Old Lady (From Pasadena)" followed in 1964. Dean sang lead on the Beach Boys' 1966 monster hit "Barbara Ann." They had 26 top 100 hits in all. In 2003, they played the Michigan State Fair in Detroit. (Frank Pettis.)

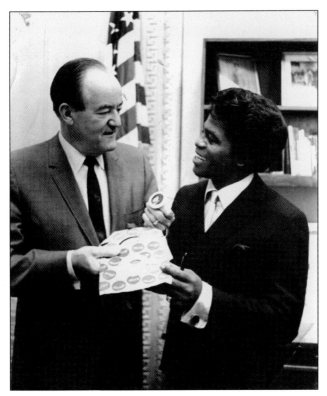

James Brown was born in Macon, Georgia, in 1928. His total hit production towered to 94 top 100 hits. Known as the "Godfather of Soul," civil rights and social causes were very important to him. In this 1966 photograph, he is pictured with Hubert Humphrey, discussing their Don't Be a Drop-Out Campaign. In 1987, Brown and Aretha Franklin performed together at the Taboo Club in Detroit. Brown died on Christmas day, 2006.

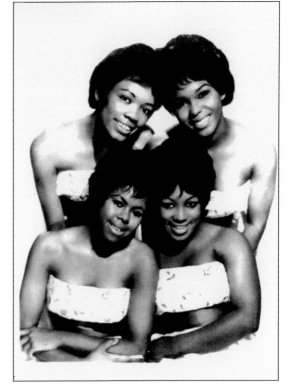

The Shirelles formed in Passiac, New Jersey, as the Poquellos, with Shirley Alston (1941), Beverly Lee (1941), Doris Kenner (1941), and Addie "Micki" Harris (1940), when they were in junior high school. They were the most successful girl group of the rock era. "Will You Love Me Tomorrow" went to No. 1 in 1960. "Soldier Boy" went to No. 1 in 1962. They also influenced the young Motown girl group the Marvelettes. The group released 26 top 100 hits. Harris died in 1982 at 42 years, and Kenner died in 2000, at 58 years. The group was inducted into the Rock and Roll Hall of Fame in 1996. (Frank Pettis.)

Hank Ballard (1936) formed his vocal group, the Royals, in Detroit in 1952. Soon, Ballard, Henry Booth, Charles Sutton, Lawrence Smith, and Sonny Woods were the Midnighters. In 1960, they had their first big hit, "Finger Poppin' Time." In 1960, they released "The Twist," written by Ballard. Chubby Checker covered their song and took it to glory. Some credit Ballard with influencing James Brown's wild stage show. In this photograph, Ballard's foot is on the piano. They recorded 13 top 100 hits. (Photograph by James J. Kriegsmann, courtesy of Frank Pettis.)

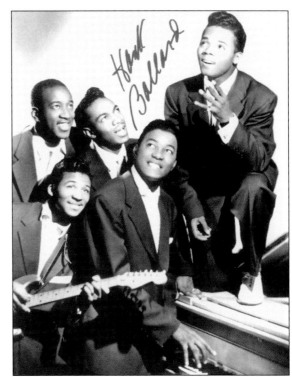

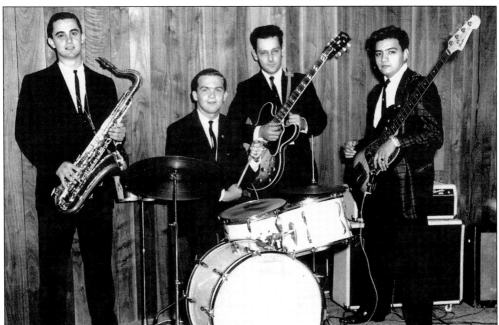

Little Joe and the Nuggets came together in 1959, in Melvindale, Michigan, with Jose Riojas (1938), bass and lead; Tony Martin, drummer; Pete Thomas, lead guitar; and Lenny, saxophone. This band, like many, recorded no No. 1 hits. Little Joe and the Nuggets broke up in 1963, but Riojas and Martin rebuilt and played together for over 20 years. During these years, they played the Roostertail and Rose's Bar, in Detroit. Martin became a doctor, and Riojas continues to play.

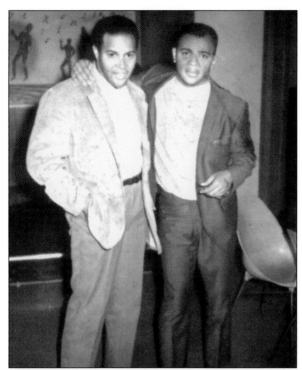

Chubby Checker (left) was born Ernest Evans, in Andrews, South Carolina, in 1941. Raised in Philadelphia, he started out doing impersonations of famous singers. In 1959, Dick Clark's wife suggested that Evans change his name to Chubby Checker. In 1960, his life changed when he released his biggest hit, "The Twist." The dance craze that followed this No. 1 hit had chiropractors writing in newspapers that it could cause paralysis. Checker recorded 35 top 100 hits. In this 1967 photograph, Checker and Detroit's Spyder Turner pose for a friend in a New York City nightclub. (Spyder Turner.)

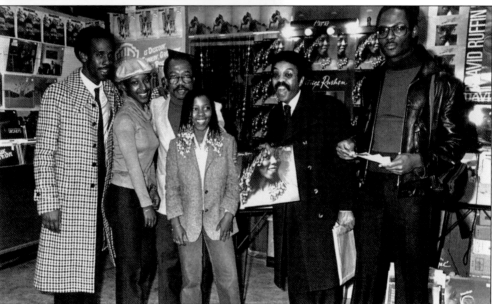

Detroit's Monroe Music store became one of America's first African American–owned record stores, when Lee Canady and his partner opened the store in downtown Detroit in 1959. In 1962, their store became the third African American–owned music store in America to qualify to buy records directly from white-owned record companies. In this 1980 photograph, Alecia (Canady's employee) stands beside owner Canady, and in front of Canady stands recording artist Patrice Rushen. Canady closed his store in 1984 as the shopping public left downtown Detroit. (Lee Canady.)

Two

THE 1960S

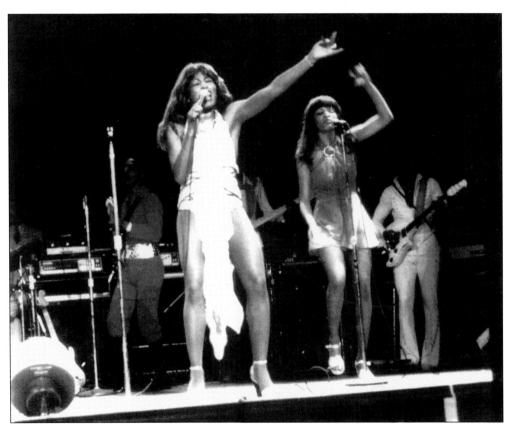

Tina Turner was born Anna Mae Bullock (1938) in Brownsville, Tennessee. She and her husband, guitarist Ike Turner, released their first hit, "A Fool in Love," in 1960. They recorded 25 top 100 hits. This photograph of Ike and Tina Turner was taken by Frank Pettis at the Michigan Palace in 1974. This concert was produced by coauthor Bob Harris. Tina's first and only No. 1 hit, "What's Love Got To Do With It," was released on the Capitol label in 1984.

Brian Hyland, born in Queens, New York, in 1943, formed the Delphis at age 12, in 1955. He had his first No. 1 hit, "Itsy Bitsy Teenie Weenie Yellow Polka Dot Bikini," in 1960. In 1962, he released "Sealed With a Kiss" and became a legend. Going into business with Michigan's Del Shannon, in 1970 and 1971, "Gypsy Woman" and "Lonely Teardrops" were released as Del Shannon Productions. Between 1960 and 1971, Hyland recorded 22 top 100 hits.

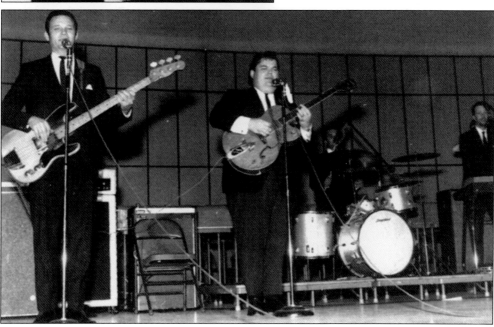

The Capris, Nick Santamaria (lead), Vinny Narcardo (baritone), Mike Mincelli (first tenor), Frank Reina (second tenor), and John Cassese (bass), were an Italian vocal group that came together in Queens, New York, in 1958. Their first of four top 100 doo-wop style hits, "There's a Moon Out Tonight," was recorded in 1960. Reduced to a quartet by 1972, the Capris are pictured at the Michigan State Fair when they performed at the ALSAC (American, Lebanese, Syrian Associated Charities) show in 1972.

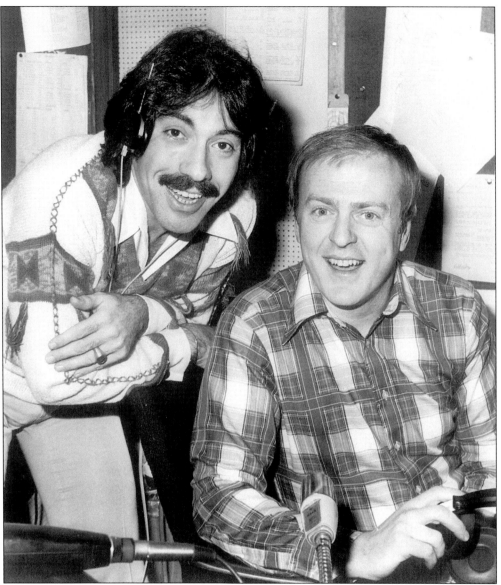

Tony Orlando (left) was born Michael Anthony Orlando Cassavitis, in Manhattan, New York, in 1944. At 16, he was discovered by producer Don Kirshner. "Halfway to Paradise" was his first top 100 hit in 1961. He scored a No. 1 hit with "Knock Three Times" in 1970. In this photograph, he kids with Detroit disc jockey Tom Shannon, of CKLW radio. He had 25 top 100 hits. In the early 1990s, Orlando opened the Tony Orlando Yellow Ribbon Music Theatre in Branson, Missouri, where he continues to perform. Tom Shannon (right), radio disc jockey, producer, and rock-and-roll promoter, from Detroit's golden age of rock, meets with Orlando, in CKLW's Windsor studio. Although CKLW is in Windsor, CKLW's 50,000 watts of broadcasting power made this station a Detroit, Midwest, and, after midnight, an eastern America radio station. Disc jockeys like Shannon met, interviewed, promoted, and aired dozens of rock stars as these rock stars passed through town during the 1960s and 1970s. (CKLW.)

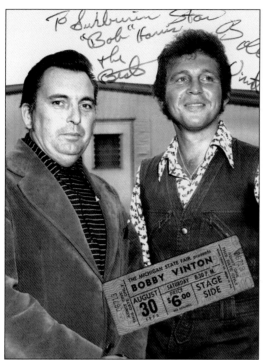

Bobby Vinton and coauthor Bob Harris are caught between acts at the 1975 Michigan State Fair. By this time, there was no doubt that Vinton had a monster career. Born in Cannonsburg, Pennsylvania, in 1935, his father was a bandleader. By 1960, Vinton was touring as the leader of Dick Clark's Caravan of the Stars. He went solo in 1962 and immediately hit No. 1 with "Roses are Red (My Love)." In 1963, he had two No. 1 hits, "Blue Velvet" and "There! I've Said It Again." In 1964, he hit No. 1 with "Mr. Lonely." Three more top 100 hits followed that year. He had 49 top 100 hits in all.

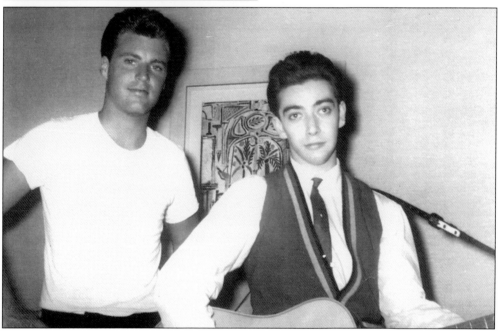

Ricky Nelson was born Eric Hilliard Nelson in Teaneck, New Jersey, in 1940, to bandleader Ozzie Nelson and singer Harriet Hilliard. His first top 100 hit was released in 1957, while he was acting and growing up (1952–1966) on television's *The Adventures of Ozzie and Harriet*. His first No. 1 hit, "Poor Little Fool," was released in 1958. He had 54 top 100 hits. In this 1961 photograph, Ricky lends his guitar to Frank Pettis, the president of Michigan's Ricky Nelson fan club. Ricky died in 1985. (Frank Pettis.)

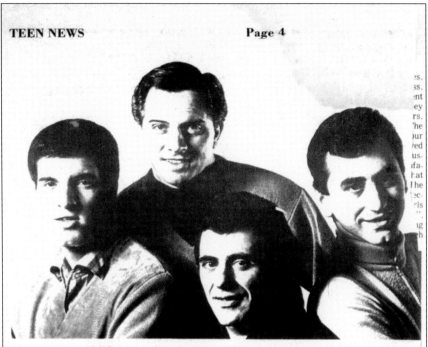

The Four Seasons

(Continued From Page 2)

group called The Four Lovers.

As a child, Bob Gaudio, second tenor, was somewhat of a protege — at the age of seven he was featured in a piano recital at Carnegie Hall. Like the other Four Seasons, Bob attended grammar and high school in New Jersey, and simultaneously studied classical piano for about seven years. His first professional stint came with The Royal Teens, the group for which he wrote "Short Shorts", his first overnight song writing success and ultimate gold record. Bob once considered his song writing a hobby — but right now he's responsible for the writing of most of The Four Seasons' hits.

first used them to provide vocal background for other recording artists, until 1962 when Bob Gaudio came up with a song that seemed a perfect vehicle for The Four Seasons' recording debut. Within one month it became a "hit". The song, "Sherry", sold over a million copies and earned the group its first gold record. After that, one hit followed another, most of them written by Bob. A listing of these include "Big Girls Don't Cry", "Walk Like a Man", "Candy Girl", "Ain't That a Shame", "Stay", "Dawn", "Rag Doll", "Save It For Me", "Bye Bye Baby", "Ronnie", "Let's Hang On", and "Workin' My Way Back to You." The result is that The Four Seasons have sold more records than any other group now recording in the

has frequently guest-starred on the Ed Sullivan, Steve Allen and Dick Clark Shows, as well as on Shindig and Hullabaloo. They have also headlined at top clubs across the country, including the famed Copacabana in New York where they added swinging adults to their ever-growing fan club.

The Four Seasons are now planning bigger and better years ahead, with an enlarged repertoire and a new club act that will have the guys in a new bag ... singing, dancing, and the works. Their favorite recording group right now is The Wonder Who?, a talented young group made up of the same four boys. You remember their big hit "Don't Think Twice", and they've just made "The Good Ship Lollipop", and "You're Nobody

The Four Seasons had 12 top 100 hits before the Beatles had their first hit in 1964. Coming together in 1955, in Newark, New Jersey, when lead singer Frankie Valli (born Francis Castelluccio in 1937) created the Variatones with twin brothers Nick and Tommy DeVito and Hank Majewski. In 1956, they changed their name to the Four Lovers. Bob Guido, formerly of the Royal Teens, joined as keyboardist in 1959. By 1961, their lineup was Valli, Guido, and Nick Massi, who replaced Majewski and Tommy DeVito. When they made their last recording in 1994, they had 48 top 100 hits. Some of their major hits include "Sherry" (1962), "Big Girls Don't Cry" (1962), "Rag Doll" (1964), and "December, 1963 (Oh What a Night)" (1975). Massi died in 2000, at 73 years. In 1990, the group was inducted into the Rock and Roll Hall of Fame. In this 1966 interview in the *Teen News*, the group talks about its music and future plans, before a concert in Detroit.

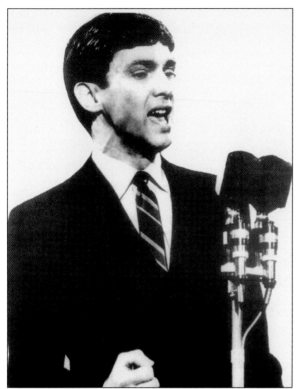

Gene Pitney was born in Hartford, Connecticut, in 1941, and raised in nearby Rockville. He first recorded in 1959 as Janice and Jane. Recording as Billy Bryan (Blaze) in 1960, he changed to his own name, Gene Pitney for Festival, that same year. Between 1961 and 1969, Pitney recorded 24 top 100 hits. In 1961, he wrote Ricky Nelson's monster hit, "Hello Mary Lou." In 1962, he wrote the Crystals' hit "He's a Rebel." In 2002, Pitney was inducted into the Rock and Roll Hall of Fame. Today he endorses Detroit radio station WHND, Honey Radio.

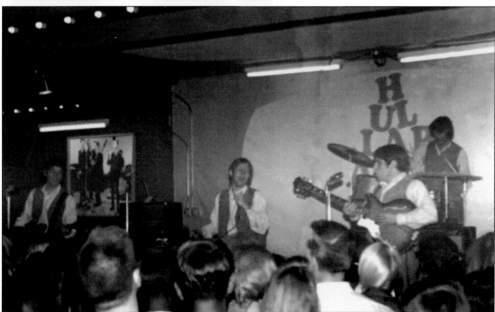

The Rationals came together in Ann Arbor in 1961. In this 1964 photograph, the Rationals are playing at Detroit's Hullabaloo Club. Scott Morgan sang and played guitar, Steve Correl played guitar, Terry Trabant played bass, and Bill Figg played drums. In 1966, they had their only top 100 hit, "Respect." They toured with the (Young) Rascals, and were voted Detroit's most popular band by WKNR listeners in 1966.

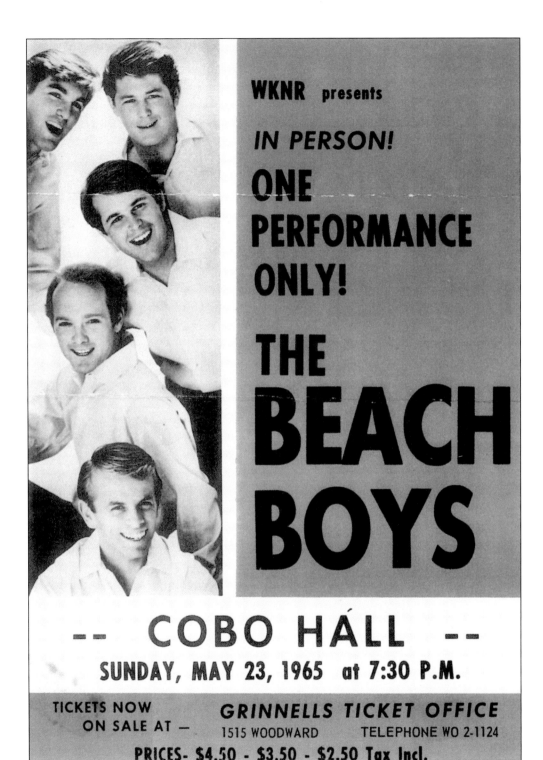

This poster advertises the Beach Boys' performance at Cobo Hall in 1965 (see page 48).

Del Shannon, singer, songwriter, and producer, was born Charles Westover, in Coopersville, Michigan, in 1934. His first hit, "Runaway," was released on the Big Top label, and it went to No. 1 in 1961. He wrote "I Go to Pieces" for Peter and Gordon, in 1965. His final top 100 hit, "Sea of Love," was produced by Tom Petty and released in 1981. Between 1961 and 1981, Shannon released 17 top 100 hits. In 1999, he was inducted into the Rock and Roll Hall of Fame. Shannon died in 1990 at 55 years. (Westover family and the Coopersville Area Historical Society Museum.)

Aretha Franklin was born in 1942, in Memphis, Tennessee, but raised in Detroit, Michigan. The daughter of the famous Rev. C. L. Franklin, she first sang in his church. She recorded her first top 100 hit in 1961. In 1967, Aretha, called the "Queen of Soul," released "Respect." It went to No. 1 and became her trademark. By 1998, Aretha had released 76 top 100 hits. She was inducted into the Rock and Roll Hall of Fame (1987) and has won Grammy's Lifetime Achievement Award (1994). She continues to perform before sold-out audiences. (Leni Sinclair.)

The Beach Boys were formed in 1961, when brothers Brian, keyboards and bass (1942); Dennis, drums (1944); and Carl Wilson (1946); joined with their cousin, Mike Love, singing lead vocals (far right, 1941) and Al Jardine (1942). They began as Kenny and the Cadets, then Carl and the Passcons, the Pendletones, and finally, the Beach Boys. Their first top 100 hit, "Surfin'," was released in 1962. They played in Detroit many times. (Capitol Industries.)

The New Christy Minstrels folk-rock group was founded by Randy Sparks in early 1962. Its first top 100 hit, "This Land is Your Land," was released in December 1962. Over the years, the members changed. In 1966, the group included Barry McGuire and Kenny Rogers (this photograph) and Kim Carnes in the late 1960s. Performing in Detroit at Cobo Hall in 1966, Bob Harris stands between the two female members of the group. Rogers is second from the right and McGuire is on the far right.

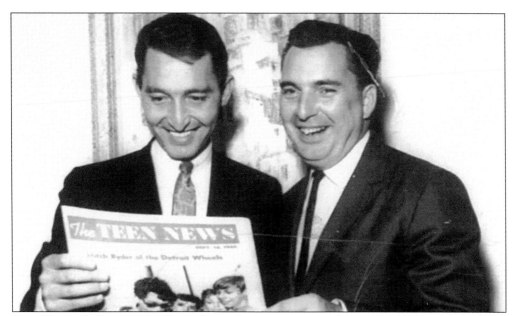

Dave "Sangoo" Prince, radio disc jockey and television personality, came to Detroit's WKMH in 1960. Two years later, he moved to WXYZ-TV, where he hosted a teen dance show on channel 7 between 1962 and 1968. Promoting rock and roll in Detroit right from the beginning, he took his voice to WCAR, where he stayed for seven years (1968–1975). After spending four years in California, he returned to Detroit's WCZY in 1980. Between 1984 and 1993, he delivered rock and roll to his audience from Windsor, Canada's CKLW radio.

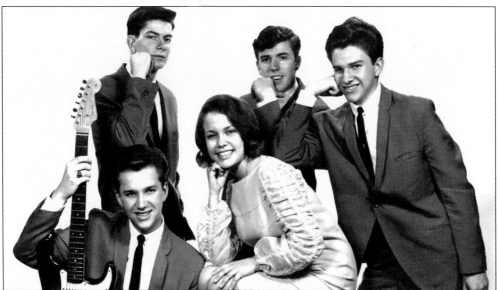

Jeff and the Atlantics, from Inkster, Michigan, formed in high school in 1962. Standing are, from left to right, drummer, Tom Terrell; rhythm guitarist, Terry DesJardins; and Mark Williams, bass; sitting are Jeff Williams, lead guitar, and Cathe Garcia, lead singer. Their biggest hit, with Gino Washington, "Gino's a Coward," went to No. 2 on the WKNR charts. They opened for the Rolling Stones at Olympia in 1965. Occasionally the group reunites to play at the MGM Grand, Motor City, and Greek Town casinos. (Photograph by Terry Thurn, courtesy of Jeff Williams.)

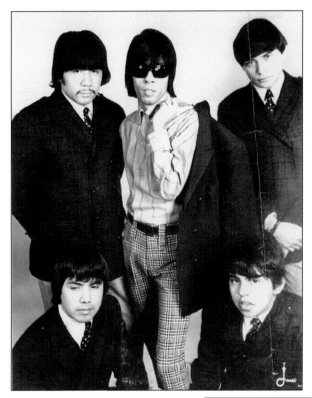

Question Mark and the Mysterians came together as a garage rock band in the Bay City, Michigan, area. Playing from 1962 to 1966 as a local favorite in the Saginaw area, few could imagine what lay ahead. Rudy "?" Martinez was lead singer, Bobby Balderrama played guitar, Frank Rodriguez played organ, Frank Lugo played bass, and Eddie Serrato played drums. Their first hit, written by Martinez, was "96 Tears," which went right to No. 1 in 1966. Three additional top 100 hits followed in 1967. ? continues to perform. (Paul Jonali.)

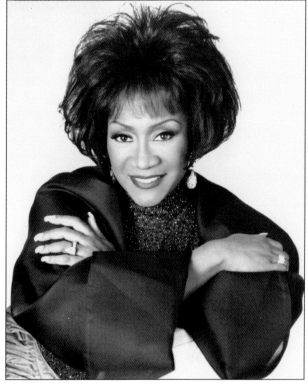

Patti LaBelle was born Patricia Holt in Philadelphia in 1944. She began her career as lead singer of the Ordettes, which morphed into the Blue Belles. This quartet was formed in Philadelphia in 1962 and included Nona Hendryx, Sarah Davis, and Cindy Birdsong. The group continued as a trio when Birdsong left in 1967 to join the Supremes. "Lady Marmalade" (1975) and "On My Own" (1986) were two No. 1 top 100 hits for LaBelle. LaBelle has scored 18 top 100 hits. (Marc Raboy.)

Iggy Pop was born James Osterberg in Muskegon, Michigan, in 1947. In 1962, Iggy Pop joined the Iguanas, a local Ann Arbor band. In 1967, with brothers Ron (guitar) and Scott Asheton (drums) and Dave Alexander (bass), Iggy Pop formed the Psychedelic Stooges. John Sinclair called the band's 1968 debut at Detroit's Grand Ballroom unbelievable. Iggy Pop and his antics, including blood, peanut butter, and twirling mike stands, were a large part of the show. In 2008, Iggy stood up for Madonna as she was inducted into the Rock and Roll Hall of Fame. (Photograph by Leni Sinclair.)

Marie Dionne Warwick(e) was born in East Orange, New Jersey, in 1940. The e was added to her last name in the early 1970s. Singing in a church choir from the age of six, she later formed Gospelaires, a trio, with her sister Dee Dee and her aunt Cissy Houston (mother of Whitney Houston). Her first top 100 hit, "Don't Make Me Over," was released in 1962. Between 1980–1981 and 1985–1986, she cohosted television's rock show Solid Gold. In 1982, she recorded an album with Detroit's Spinners. Warwicke recorded 56 top 100 hits.

Ray Stevens was born Harold Ray Ragsdale in Clarksdale, Georgia, in 1939. More country than rock, his early hits and songwriting mandate his inclusion here. "Ahab, the Arab," was released in June 1962. This song was a big hit with Detroit's Arab American community. The summer of 1962 saw this song on charts for 11 weeks. His syrupy No. 1 hit "Everything is Beautiful" was released in 1970. Ray Stevens had 28 top 100 hits.

Linda Kay, born Linda Campbell, was a 14-year-old Detroiter when she signed a three-year contract with Universal Records in 1963. Coauthor Bob Harris was her manager. Her first releases were "Torture" and "I Don't Want to Be Alone," followed by "But It's Not True" and "Too Many Days." She was a popular performer at Detroit area venues. Kay was last seen modeling cars for Chrysler at the Michigan State Fair in the late 1960s. Rock and roll flirts with many musicians but marries few.

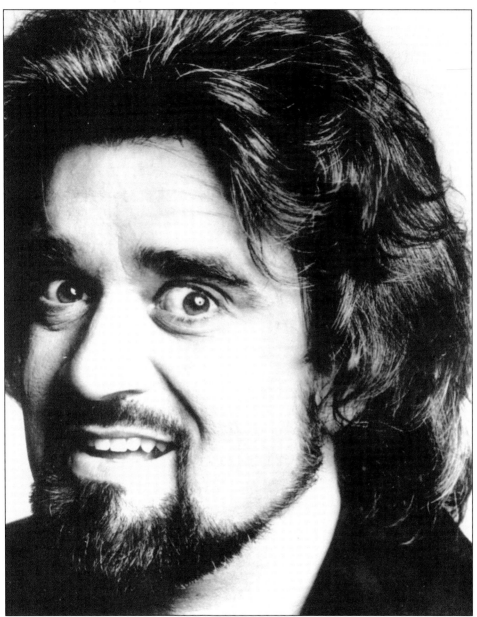

Wolfman Jack was born Robert Weston Smith in 1938. This gravelly voiced disc jockey became world famous in the 1960s and 1970s under the Wolfman Jack name and influenced Detroiter's record buying choices. As a fan of flamboyant disc jockey Alan Freed, it did not take Smith long to adapt Freed's wolf howl, plus his own side effects, into the Wolfman Jack persona. Smith's character was also partly based on the manner of Howling Wolf, the bluesman. Wolfman Jack was so associated with the rock and roll of the 1960s that director George Lucas cast Wolfman Jack as himself in Lucas's 1973 film *American Graffiti*. In July 1974, Wolfman Jack was the emcee for the Ozark Music Festival, a huge three-day rock festival with 350,000 attendees, making it one of the largest music events in history. Wolfman Jack died of a heart attack in 1995 at 57 years. In 1996, Wolfman Jack was inducted into the Radio Hall of Fame. His shows are aired in Detroit today on XM satellite radio. (Frank Pettis.)

Lesley Gore was born in New York City in 1946 and was raised in Tenafly, New Jersey. Discovered by Quincy Jones while singing in a hotel lounge in the early 1960s, she recorded 19 top 100 hits. In 1963, her first top 100 hit, "It's My Party," became her biggest hit. "You Don't Own Me," another monster hit, was a slow dance, released in December 1963, and was first aired by Detroit's WKNR. She had movie roles in *Girls on the Beach* and *Ski Party*. After years of quiet, Gore recorded an album of her own material in 2005.

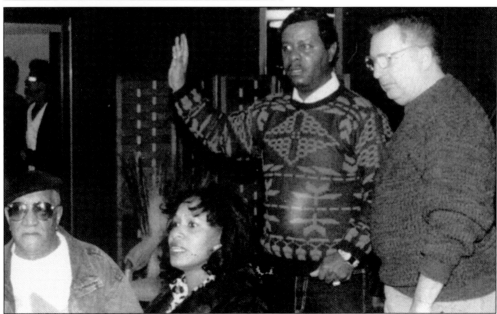

Gino Washington, born in Detroit in 1946, became a well-known rock vocalist and songwriter. He played Cobo Hall in the late 1960s, and his big hit record, "Gino's a Coward," was released in 1963. In this late 1970s photograph, from left to right, Redd Foxx, Washington's sister Shirley, Washington, and Bob Harris meet after a Redd Foxx benefit, as the IRS had just seized Foxx's house in a tax dispute. Washington, with his beautiful voice, continues to perform today.

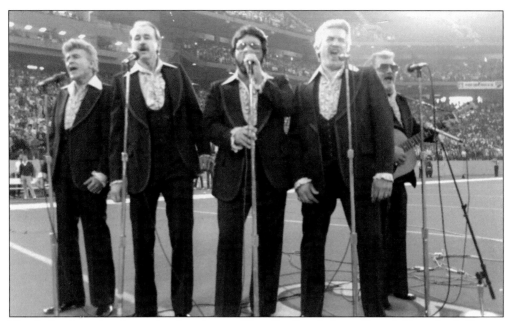

The Reflections sing the national anthem at Tiger Stadium before a Detroit Lions football game in the early 1970s. Founded in 1955 by Gary Banovetz, the original members included lead singer Tony Micale, Dan Bennie, Ray Steinberg, and Phil Castrodale. Their biggest hit, "(Just Like) Romeo and Juliet," went to No. 6 in the top 100 charts. In this photograph are, from left to right, Gary Banovetz, Bernie Turnbull, John Dean, Tony Micale, and Tommy Hurst. Turnbull and Hurst have passed. The group now pforms as the Larados.

The Shangri-las were formed, from left to right, by Betty Weiss, Mary Ann and Marge Ganser, and Mary Weiss, in Queens, New York, in 1964. That year they had a monster No. 1 hit with "Leader of the Pack." They had 11 top 100 hits and when they played Detroit, they used Iggy Pop's band as backup. Mary Ann died in 1971, and Marge died in 1996, at 48 years. (Photograph by Bruno of Hollywood, courtesy of Frank Pettis.)

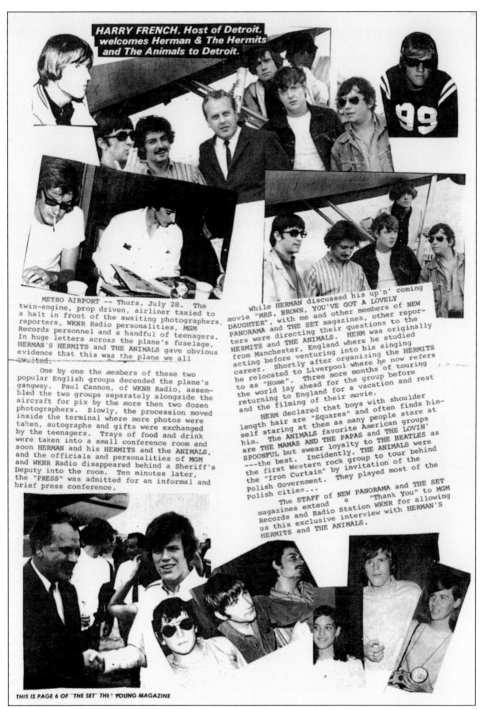

HARRY FRENCH, Host of Detroit, welcomes Herman & The Hermits and The Animals to Detroit.

METRO AIRPORT -- Thurs. July 28. The twin-engine, prop driven, airliner taxied to a halt in front of the awaiting photographers, reporters, WKNR Radio personalities, MGM Records personnel and a handful of teenagers. In huge letters across the plane's fuselage, HERMAN'S HERMITS and THE ANIMALS gave obvious evidence that this was the plane we all awaited.

One by one the members of these two popular English groups decended the plane's gangway. Paul Cannon, of WKNR Radio, assembled the two groups separately alongside the aircraft for pix by the more then two dozen photographers. Slowly, the procession moved inside the terminal where more photos were taken, autographs and gifts were exchanged by the teenagers. Trays of food and drink were taken into a small conference room and soon HERMAN and his HERMITS and the ANIMALS, and the officials and personalities of MGM and WKNR Radio disappeared behind a Sheriff's Deputy into the room. Ten minutes later, the "PRESS" was admitted for an informal and brief press conference.

While HERMAN discussed his up'n' coming movie "MRS. BROWN, YOU'VE GOT A LOVELY DAUGHTER", with me and other members of NEW PANORAMA and THE SET magazines, other reporters were directing their questions to the HERMITS and THE ANIMALS. HERM was originally from Manchester, England where he studied acting before venturing into his singing career. Shortly after organizing the HERMITS he relocated to Liverpool where he now refers to as "Home". Three more months of touring the world lay ahead for the group before returning to England for a vacation and rest and the filming of their movie.

HERM declared that boys with shoulder length hair are "Squares" and often finds himself staring at them as many people stare at him. The ANIMALS favorite American groups are THE MAMAS AND THE PAPAS and THE LOVIN' SPOONFUL but swear loyalty to THE BEATLES as ---the best. Incidently, THE ANIMALS were the first Western rock group to tour behind the "Iron Curtain" by invitation of the Polish Government. They played most of the Polish cities...

The STAFF of NEW PANORAMA and THE SET magazines extend a "Thank You" to MGM Records and Radio Station WKNR for allowing us this exclusive interview with HERMAN'S HERMITS and THE ANIMALS.

THIS IS PAGE 6 OF "THE SET" THE YOUNG MAGAZINE

Harry French, "Host of Detroit," was the *Detroit Free Press* music writer in the 1960s and a mover and shaker in the 1960s rock scene. He also wrote for coauthor Bob Harris's *Teen News* and managed Jerry Plunk and the Flaming Ember, a group from Detroit. French is the man with the tie in the above photograph. This newspaper page is taken from the *Set*, August 4, 1966, a teen newspaper that was in business for about two months in 1966.

Mitch Ryder, harmonica, was born William Levise Jr. in Detroit on February 26, 1945. Ryder was lead singer, with Jim McCarty and Joe Kubert on guitar, Earl Elliot on bass, and Johnny "Bee" Badanjek on drums. Originally known as Billy Lee and the Rivieras, this band hit its peak and lost its center in 1967. "Devil with a Blue Dress On" and "Little Latin Lupe Lu" are two of the group's biggest hits. Mitch Ryder continues to perform before enthusiastic crowds. (Photograph by Bruno of Hollywood, courtesy of Frank Pettis.)

Gary Lewis was born Gary Levitch, the son of comedian and film star Jerry Lewis, in 1945. Gary Lewis and the Playboys were formed in 1964 and played regularly at Disneyland. Lewis played drums and sang vocals. Their first hit, "This Diamond Ring," went to No. 1 on the charts. They had 15 top 100 hits. In this photograph, Bob Harris and Lewis scan a copy of Harris's *Teen News*. Detroit's Robin Seymour and Lewis's father, Jerry Lewis, are pictured on the cover.

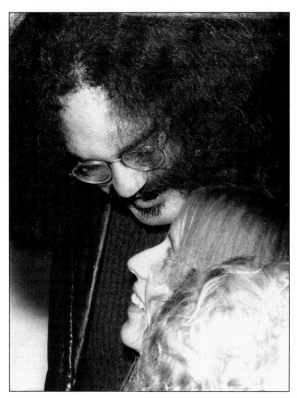

John and Leni Sinclair were political, cultural, and rock influences on 1960s and 1970s Detroit and the national scene. Leni Arndt, poet, filmmaker, and photographer, married John in 1965, and they worked as a team on projects such as the Detroit Artists' Workshop. He helped create and manage the MC5. Michigan's leading radical, John, divorced from Leni in 1975, gives readings of his poetry across the United States and Europe. Leni lives in Detroit where she works as a photographer and sells photographs from her jazz and rock archives. This photograph was taken in Ann Arbor in 1972. (Leni Sinclair.)

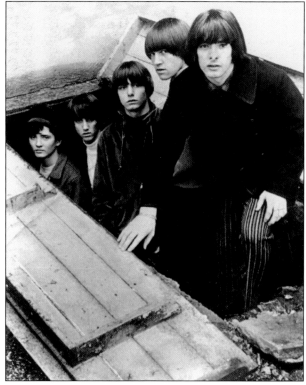

Terry Knight (Knapp) and the Pack formed in Flint, Michigan, in 1965. Its members were Knight (right), Curt Johnson, Bobby Caldwell, Mark Farner, and Don Brewer. Their first top 100 hit, "I (Who Have Nothing)," was released in 1966. Knight stopped performing with the Pack and became the manager of a reconfigured group, which was renamed Grand Funk Railroad, after Michigan's Grand Trunk Railroad. Sadly Knight was stabbed to death by his daughter's boyfriend in 2004.

Radio disc jockey Dick Purtan is Michigan's most respected and recognized on-air personality. A native of Buffalo, "Paul" Purtan worked at WOLF (Syracuse) and WSAI (Cincinnati) before coming to Detroit to work a late-night slot at WKNR, a top 40 station that was an early and strong supporter of rock and roll. Paul became Dick on arriving in Detroit in 1965. The station already employed a Paul Purtan. Dick Purtan and Purtan's People currently work the morning drive-time slot on WOMC, Detroit. Today's show emphasizes humor and conversation as well as classic rock. In this rare photograph from the 1960s, Dick is not yet sporting his trademark mustache.

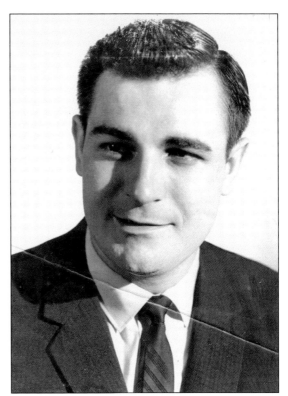

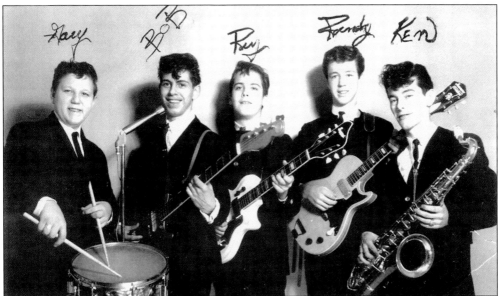

The Invictas came together in Detroit in 1964. Gary Sander (drums), Bob Adamski (singer), Ray Goodman (bass, 14 years old in this photograph), Randy Bazzel (rhythm guitar), and Ken Hutchinson (saxophone) rounded out this popular Michigan band. In 1965, their group won first place in a battle of the bands at the Michigan State Fair. Coauthor Bob Harris was their manager. Goodman currently works as a hi-tech sound engineer, preserving recordings from the early 1900s to today. (Ray Goodman.)

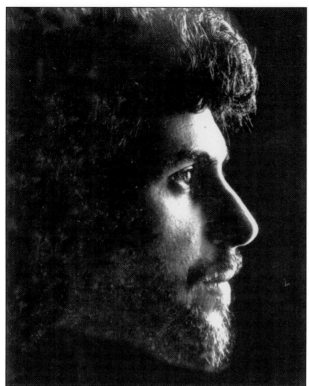

Johnny Rivers was born John Ramistella in New York City in 1942. Raised in Baton Rouge, Louisiana, this rock-and-roll singer, guitarist, producer, and songwriter made his first recording with the Spades of Suede in 1957. Dubbed "Johnny Rivers" in 1958 by disc jockey Alan Freed, he had his first top 100 hit, "Memphis" (a Chuck Berry cover), in 1964. His song "Maybelline" first aired on Detroit's WKNR on August 6, 1964.

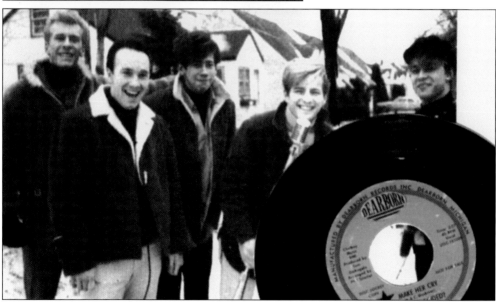

The Runarounds (the Undecided) came together in 1963 when high schoolers from Redford and Livonia, Michigan, formed, seen here from left to right, with Rick on drums, Ron Copeland on bass, Chuck and Ron Blackmer on lead guitar and lead vocals, and Terry Stump on rhythm guitar. In 1966, they changed their name to the Undecided and soon after recorded "Make Her Cry." Things came to a halt in 1969 when Rick and Terry Stump got drafted. Copeland currently lives in Southgate, Michigan. (Ron Copeland.)

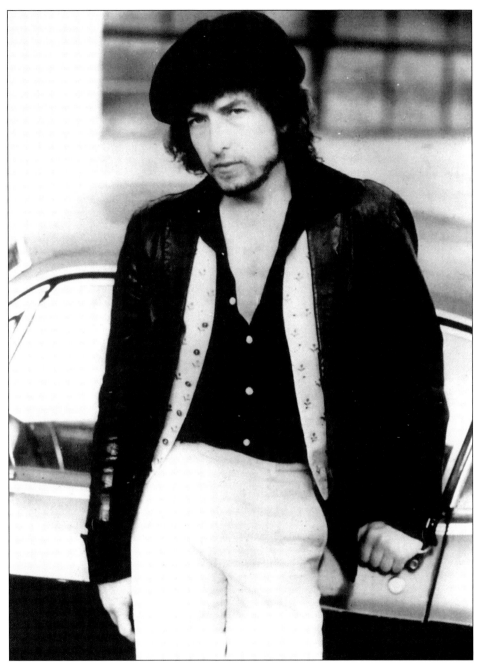

Bob Dylan was born Robert Zimmerman in Duluth, Minnesota, in 1941. A Poet, priest, revolutionary, and an influence on generations of rock stars, this man often appears mystical, if not confusing. His first top 100 hit, "Subterranean Homesick Blues," released in 1965, immediately established Dylan as major talent. Dylan was a charter member of the supergroup the Traveling Wilburys. He regularly performs in the greater Detroit area. In 1988, he was inducted into the Rock and Roll Hall of Fame, and in 1991, he received Grammy's Lifetime Achievement Award. Although Dylan has never had a No. 1 hit, his intellectual power establishes him as a unique rock icon who continues to perform before sell out crowds. (Frank Pettis.)

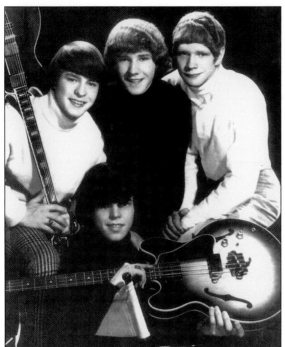

The McCoys formed in Union City, Indiana, in 1964. Rick Zehringer, vocals and guitar, and his brother Randy, on drums, joined with Buddy Hobbs, bass, and Ronnie Brandon, keyboards. They had their first and biggest hit in 1965, "Hang On Sloopy," which went to No. 1 on charts. This hit opened at 11 when it first aired on Detroit's WKNR. Their last hit was in 1968. Seven more top 100 hits followed. Randy Hobbs died in 1993 at 45 years.

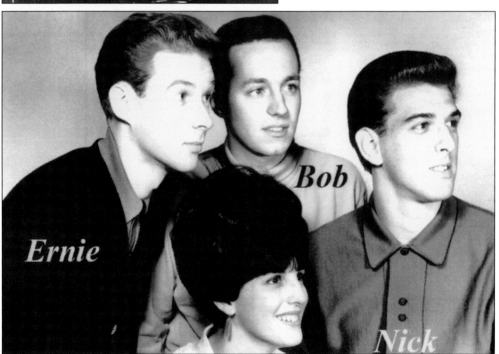

Shades of Blue came together in Detroit with Linda and Robert Kerr, Ernest Demai, and Nick Marinelli in 1965. Their first and biggest hit, "Oh How Happy," was released in 1966. Two more top 100 hits were released that same year. The band broke up for the first time in 1971. A brief reunion happened in 1977. In 2002, original member Marinelli reconstituted the group, which continues to perform 50 dates a year. Robert died in 2006. (Nick Marinelli.)

Bob Layne (1943), radio disc jockey, began his broadcast career as a 14 year old while at Utica High School, in Utica, Michigan. He worked his way through Wayne State University, selling voice-overs, disc jockey work at a Flint station, and on-air work at Detroit's WJR. When this mid-1960s photograph was taken, Layne was playing rock and roll for southeast Michigan on WJBK-Radio-15. After getting a law degree from Wayne State University, Bob Layne, whose real name is Robert Liggett Jr., bought station WFMK in Lansing, Michigan. From this seed, the Liggett Broadcast Group grew.

When Bob Liggett sold his company, the Liggett Broadcast Group, 30 years later in 2000, it had almost 30 stations in Michigan, Ohio, Minnesota, New York, and California. This business feat is one of the largest in the history of rock and broadcasting. Not about to retire, Liggett came to the rescue of the Michigan-based Big Boy restaurant chain in 2001. Thank you, Mr. Liggett, for sharing your talents with fans of rock, and fans of Big Boy restaurants.

Sam the Sham and the Pharaohs were formed in Dallas in the early 1960s. Domingo "Sam" Samudio included Ray Stinnet, David Martin, Jerry Patterson, and Butch Gibson in his Pharaohs. "Wooly Bully," originally released on the XL label in 1964, was rereleased on April 3, 1965, on the MGM label. In July 1965, Sam the Sham played Detroit's Cubo Arena. The group had nine top 100 hits. In later years, Sam became a street preacher in Memphis. (Bruno of Hollywood.)

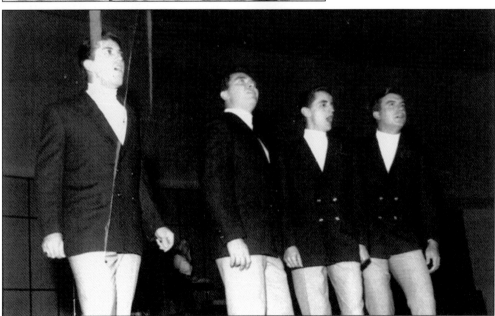

The Vogues, from Turtle Creek, Pennsylvania, formed in high school in 1960. Bill Burkette (lead), Chuck Blasko and Hugh Geyer (tenors), and Don Miller (baritone) had their first top 100 hit, "You're the One," in 1965. "Special Angel" (1968) and "Turn Around, Look at Me" (1968) are some of their best-remembered hits. Their "Five O'Clock World" is famous as the theme song of the *Drew Carey Show*. This photograph is from their Cobo Hall performance in 1965.

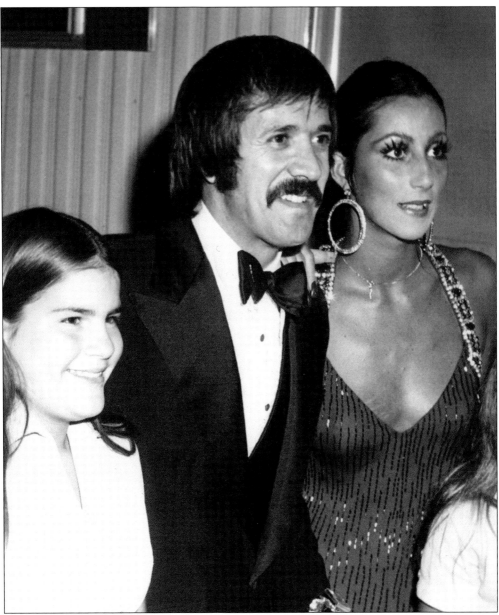

Sonny and Cher Bono were a husband and wife duo. Sonny Bono, born in 1935, and Cheryl Sarkisian La Piere, born in 1946, began as session singers for Phil Spector. Their first recording was performed under the names Caesar and Cleo. Their first top 100 hit, "I Got You Babe," was released in 1965. "The Beat Goes On" (1967) and "All I Ever Need Is You" (1971) are among the best remembered of their 20 top 100 hits. Married in 1963 and divorced in 1974, Cher went on to a very successful solo career with 29 more top 100 hits, including, "Bang Bang (My Baby Shot Me Down)" (1966), "Half-Breed" (1973), and "If I Could Turn Back Time" (1989). Cher went on to make successful movies, winning two Academy Awards. Cher still performs. In 1994, Sonny was elected to the U.S. House of Representatives but tragically died in a skiing accident in 1999. In this 1972 photograph, Sonny and Cher are with young fans at the Michigan State Fair, where they performed.

The Fifth Dimension formed in Los Angeles in the mid-1960s. Marilyn McCoo (1943), Florence LaRue (1944), Billy Davis Jr. (1940), Lamont McLemore (1940), and Ron Townson (1933) were called the Versatiles in 1966. In 1965, they presented a tape to Detroit's Motown Records but were rejected. Their biggest hit, "Aquarius/Let the Sunshine In," was released in 1969. McCoo and Davis married in 1969 and have recorded as a duo since 1976. The Fifth Dimension had 30 top 100 hits.

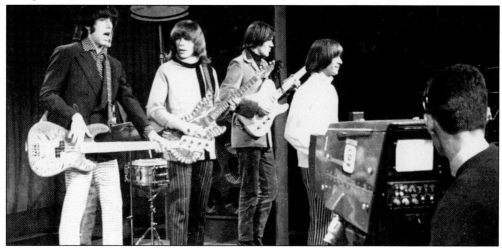

The Blues Magoos had four top 100 hits in the 1960s. This early, psychedelic-rock group came from the Bronx, New York. Their biggest hit, "(We Ain't Got) Nothing Yet," was released in 1966. In this photograph, lead singer Peppy Castro (Emil Thielhelm) and band play live in Detroit on Robin Seymour's *Swingin Time* CKLW-TV show in 1967. The band's original name was the Bloos Magoos. Later the group was renamed Balance. As Balance, they had two top 100 hits in 1981.

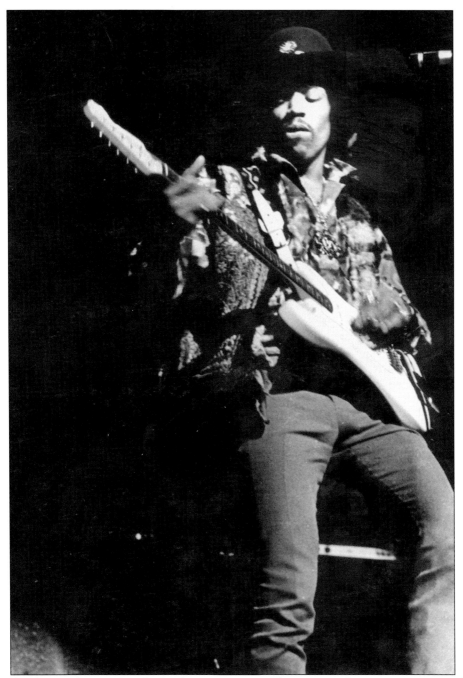

Jimi Hendrix was born in Seattle, Washington, in 1942. This guitar and expressive genius was lost too young, dying of a drug overdose in 1970 at 27 years. He was discovered by one of the Animals and was invited to England, where he created the Jimi Hendrix Experience. Jimi hit it big at Woodstock, with his unforgettable "Star Spangled Banner." His first top 100 hit, "Purple Haze," was released in 1967. In 1968, he released "All Along the Watchtower." In 1992, he was inducted into the Rock and Roll Hall of Fame and received Grammy's Lifetime Achievement Award. In this 1968 photograph, Hendrix is captured playing at Detroit's Masonic temple. (Leni Sinclair.)

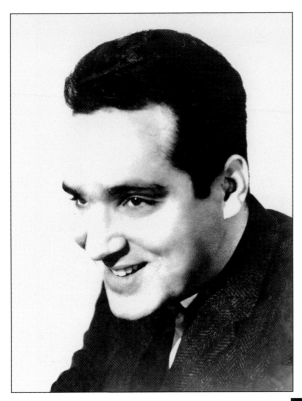

Scott Regan was a disc jockey for WKNR when this photograph was on the cover of the April 29, 1966, issue of the *Teen News*. WKNR, 1300 on the AM dial, was the No. 1 rock radio station in greater Detroit in the 1960s.

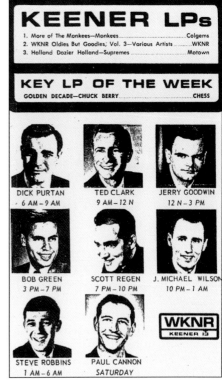

Regan's KNR colleagues are pictured in this July 18, 1968, "Keener Guide." Each week, rock fans would get their "Keener Guides" to see where their favorite musicians and songs stood. Disc jockey's did more to advance rock and roll than to send songs out over the airways. Many disc jockey's, including Regan, acted as emcees, band management, and concert promoters for charities or personal income.

This WKNR music guide for the week of July 18, 1968, shows Mason Williams and his single "Classical Gas" at the top of the charts. This station was an early and leading radio station in popularizing the new and controversial sounds of rock and roll.

WKNR
MUSIC GUIDE
WEEK OF JULY 18, 1968

1.	CLASSICAL GAS—MASON WILLIAMS	W-7	(4)
2.	GRAZING IN THE GRASS—HUGH MASEKELA	UNI	(3)
3.	JOURNEY TO THE MIND—AMBOY DUKES	MAINSTREAM	(1)
4.	HELLO I LOVE YOU—DOORS	ELEKTRA	(6)
5.	LADY WILLPOWER—UNION GAP	COLUMBIA	(2)
6.	SUNSHINE OF YOUR LOVE—THE CREAM	ATCO	(27)
7.	PICTURES OF MATCHSTICK MEN—STATUS QUO	CADET	(5)
8.	HURDY GURDY MAN—DONOVAN	EPIC	(7)
9.	STONED SOUL PICNIC—5TH DIMENSION	SOUL CITY	(10)
10.	SUNDAY MORNING 6 A.M.—CAMEL DRIVERS	TOP DOG	(12)
11.	PEOPLE GOT TO BE FREE—THE RASCALS	ATLANTIC	(20)
12.	GOOD OLD MUSIC—PARLIAMENTS	REVILOT	(16)
13.	BREAKING DOWN THE WALLS—BANDWAGON	EPIC	(13)
14.	Jumpin' Jack Flash—Rolling Stones	London	(11)
15.	Keep Me Hangin' On—Vanilla Fudge	Atco	(31)
16.	Born To Be Wild—Steppenwolf	Dunhill	(25)
17.	Love Makes A Woman—Barbara Acklin	Brunswick	(19)
18.	Dream A Little Dream—Mama Cass	Dunhill	(29)
19.	Tuesday Afternoon—Moody Blues	Deram	(21)
20.	Baseball Game—Intruders	Gamble	(22)
21.	Save The Country—Laura Nyro	Columbia	(23)
22.	Anyway You Want Me—American Breed	Acta	(28)
23.	1-2-3 Red Light—1910 Fruitgum Co.	Buddah	(30)
24.	Little Innocent Girl—Excels	Carla	(26)
25.	Mr. Businessman—Ray Stevens	Monument	(KS)
26.	Light My Fire—Jose Feliciano	RCA	(HP)
27.	Yesterday's Dreams—Four Tops	Motown	(HP)
28.	Morning Dew—Lulu	Epic	(HP)
29.	Mrs. Bluebird—Eternity's Children	Tower	(HP)
30.	Singles Game—Jay & Techniques	Smash	(HP)
31.	M'Lady—Sly & Family Stone	Epic	(HP)

KEY SONG OF THE WEEK
MAGIC BUS—THE WHO DECCA

() Indicates last week's position (HP) — Hit Preview

THE PUMPKIN

Featuring
K. J. KNIGHT AND
THE KNIGHT RIDERS

LADIES DAY THURS. ½ PRICE
SCOTT REGAN
Starting Oct. 9 Playing Requested
Records and Bringing You Guest Recording Artists
Go-Go Girls (live Too)
Exotic Drinks (Live But Not Alcoholics)
Surprise Guest Artists (Mostly Live)
No Alcohol But Come In and See
How Much Fun You Can Have Without It!
920 Wayne Road Nankin Township

OPEN
THURS., FRI., SAT., SUN.
7:00 P.M. TO 12:00 A.M.

DENNY MANGO
AT THE PUMPKIN

The Pumpkin was a popular club in the Detroit suburb of Wayne in the 1960s. In 1967, Regan moonlighted at the Pumpkin as an in-house disc jockey and emcee. In this newspaper advertisement, he promises to play requests and to bring guest recording artists. Regan and his disc jockey colleagues, along with rock writers and television music shows, were the apostles of early rock.

The Woolies came from East Lansing, Michigan, and were one-hit wonders but beloved locally. When Chuck Berry came to the Midwest to perform, the Woolies were his backup band. The group's only top 100 hit, "Who Do You Love" was released in 1966. This was the group's only top 100 hit. This 1966 photograph shows, from left to right, Bob Baldori, Jeff Baldori, and Bee Metros. Lead vocalist Stormy Rice is in front, center. They released two albums, *Basic Rock* (1970) and *Live at Lizards* (1973) were released on the Spirit label.

Dwight "Spyder" Turner was born in Beckley, West Virginia, in 1947. Starting to sing at five years, he was influenced by television appearances of Jackie Wilson and Elvis Presley. In 1966, he had his first of two top 100 hits, "Stand by Me" in 1966 and "I Can't Make It Anymore" in 1967, a song written by Gordon Lightfoot. Back in Detroit since 2004, Spyder Turner Singers and the Web Brothers Band still perform. In this 1967 photograph, courtesy of Turner, he is on stage at the Atlanta Civic Center.

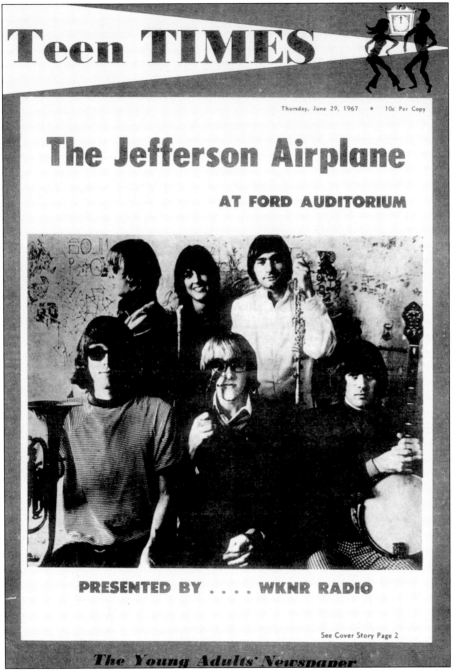

Teen TIMES

Thursday, June 29, 1967 • 10c Per Copy

The Jefferson Airplane

AT FORD AUDITORIUM

PRESENTED BY WKNR RADIO

See Cover Story Page 2

The Young Adults' Newspaper

The Jefferson Airplane first came to Detroit on June 30, 1967, to play Ford Auditorium. Sharing the stage that night were the Rationals, the MC5, the Apostles, and Ourselves. In the article that ran in this issue of the *Teen Times*, the Jefferson Airplane is described as "a San Francisco hippie group . . . composed of five guys and one girl from the Haight Ashbury district." The original members, Marty Balin (1942), Grace Slick (1939), Paul Kantner (1941), Jorma Kaukonen (1940), Jack Casady (1944), and Spencer Dryden, are all pictured here. From their first top 100 hit, "Somebody to Love," released in 1967, the Jefferson Airplane has had 38 top 100 hits.

TRANS-LOVE ENERGIES

"gets you there on time"

4857 JOHN LODGE DETROIT, MICHIGAN 48201 (313) 831-6840

17 July 1967

The Teen Times
Bob Harris, Editor
7832 Michigan Avenue
Detroit, Michigan

Dear Mr. Bob Harris:

I talked with one of your photographers at the Airplane concert at Ford
Auditorium June 30 about your newspaper and was shown a copy, which
I dug. I'd like to receive the paper regularly, and if it interests you would
like to exchange copies of the TEEN TIMES for our own newspaper,
THE SUN, which is published irregularly.

I would also be interested in writing for you if you would likewise be
interested. My interest would be in a more or less regular rock column
which would incorporate short reviews, news, fact and opinion. Could you
use anything like that? Please let me know.

Thank you.

Yours,

John Sinclair

John Sinclair

Enc: THE SUN #4

The *Sun* was one of the Sinclairs' several publishing ventures. In this 1967 letter to coauthor
Bob Harris, John Sinclair invites an exchange of newspapers and solicits another writing gig. He
already had a music column in the *Fifth Estate*. His tastes ran from blues, to jazz, and ultimately
to rock. He met MC5 members when they challenged one of his anti-rock editorials. After
listening to them rehearse, Sinclair became a fan, advisor, and ultimately, their manager and
promoter. In 1967, the Sinclairs and their friends created a commune called Trans-Love Energies
Unlimited (TLE). This name inspired Donovan's song lyric, "Fly Trans-Love Airlines." To fund
TLE, they planned to promote rock concerts, provide light shows, and publish posters, books, and
a newspaper, the *Warren-Forest Sun*, named after streets on the Wayne State University campus.

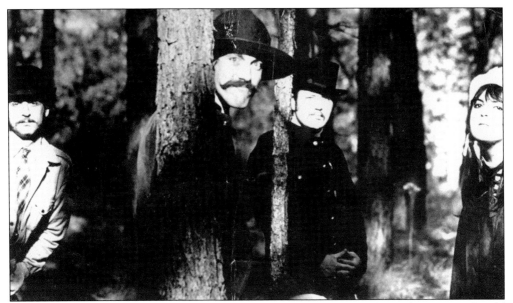

Spanky and Our Gang came out of Chicago in 1967 and was named after a character in the old *Little Rascals* television series. The original group was comprised of Elaine "Spanky" McFarlane (1942), Lefty Baker, Malcolm Hale, Nigel Pickering, Kenny Hodges, and John Seiter. Pictured here from left to right are Pickering, Oz Bach, Hale, and Spanky. "Sunday Will Never Be the Same," their biggest hit, was released in 1967. Terry Cashman, a minor league baseball player in the Detroit Tiger's organization, cowrote this bit.

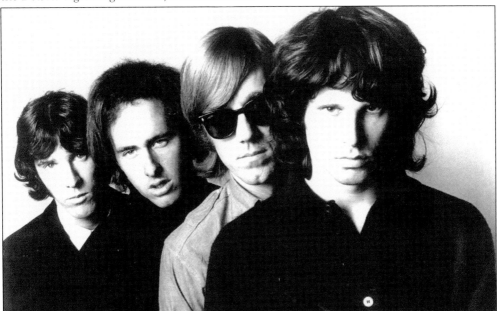

The Doors were formed in Los Angeles, seen here from left to right, by Jon Densmore (drums, 1944), Robbie Krieger (guitar, 1946), Ray Manzarek (keyboards, 1935), and Jim Morrison (vocals, 1943), in 1966. Their first hit, "Light My Fire," went to No. 1 in 1967. Their 1970 album *Live in Detroit* was recorded at Detroit's Cobo Hall. Morrison left the group in 1970. On July 3, 1971, he died of heart failure in a Paris hotel room. (Photograph by Joel Brodsky, courtesy of Frank Pettis.)

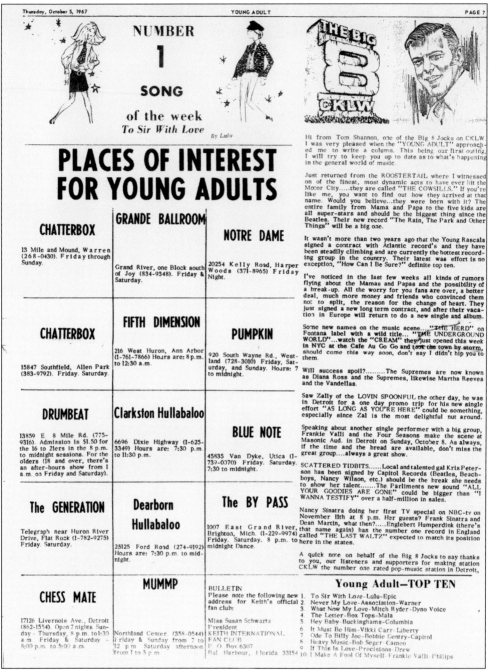

NUMBER 1 SONG

of the week
To Sir With Love
By Lulu

PLACES OF INTEREST FOR YOUNG ADULTS

CHATTERBOX

13 Mile and Mound, Warren (268-0430). Friday through Sunday.

CHATTERBOX

15847 Southfield, Allen Park (383-9792). Friday. Saturday.

DRUMBEAT

13859 E. 8 Mile Rd. (775-9316). Admission is $1.50 for the 16 to 21ers in the 8 p.m. to midnight sessions. For the olders (18 and over, there's an after-hours show from 1 a.m. on Friday and Saturday).

The GENERATION

Telegraph near Huron River Drive, Flat Rock (1-782-9275) Friday. Saturday.

CHESS MATE

17126 Livernois Ave., Detroit (862-1554). Open 7 nights Sunday – Thursday, 8 p.m. to 1:30 a.m. Friday & Saturday - 8:00 p.m. to 5:00 a.m.

GRANDE BALLROOM

Grand River, one Block south of Joy (834-9348). Friday & Saturday.

FIFTH DIMENSION

216 West Huron, Ann Arbor (1-761-7866) Hours are: 8 p.m. to 12:30 a.m.

Clarkston Hullabaloo

6696 Dixie Highway (1-625-3349) Hours are: 7:30 p.m. to 11:30 p.m.

Dearborn Hullabaloo

25125 Ford Road (274-9192) Hours are: 7:30 p.m. to midnight.

MUMMP

Northland Center. (358-0544) Friday & Sunday from 7 to 12 p.m. Saturday afternoon from 1 to 5 p.m.

NOTRE DAME

20254 Kelly Road, Harper Woods (371-8965) Friday Night.

PUMPKIN

920 South Wayne Rd., Westland (728-3010) Friday, Saturday, and Sunday. Hours: 7 to midnight.

BLUE NOTE

45835 Van Dyke, Utica (1-733-0070) Friday. Saturday. 7:30 to midnight.

The BY PASS

1007 East Grand River, Brighton, Mich. (1-229-9974) Friday. Saturday. 8 p.m. to midnight Dance.

BULLETIN
Please note the following new address for Keith's official fan club:

Miss Susan Schwartz
President
KEITH INTERNATIONAL
FAN CLUB
P. O. Box 6307
Bal Harbour, Florida 33154

Hi from Tom Shannon, one of the Big 8 Jocks on CKLW. I was very pleased when the "YOUNG ADULT" approached me to write a column. This being our first outing, I will try to keep you up to date as to what's happening in the general world of music.

Just returned from the ROOSTERTAIL where I witnessed on of the finest, most dynamic acts to have ever hit the Motor City.....they are called "THE COWSILLS." If you're like me, you want to find out how they arrived at that name. Would you believe...they were born with it? The entire family from Mama and Papa to the five kids are all super-stars and should be the biggest thing since the Beatles. Their new record "The Rain, The Park and Other Things" will be a big one.

It wasn't more than two years ago that the Young Rascals signed a contract with Atlantic record's and they have been steadily climbing and are currently the hottest recording group in the country. Their latest wax effort is no exception, "How Can I Be Sure?" definite top ten.

I've noticed in the last few weeks all kinds of rumors flying about the Mamas and Papas and the possibility of a break-up. All the worry for you fans are over, a better deal, much more money and friends who convinced them not to split, the reason for the change of heart. They just signed a new long term contract, and after their vacation in Europe will return to do a new single and album.

Some new names on the music scene... "THE HERD" on Fontana label with a wild title... "THE UNDERGROUND WORLD"...watch the "CREAM" they just opened this week in NYC at the Cafe Au Go Go and took the town by storm, should come this way soon, don't say I didn't hip you to them.

Will success spoil?.........The Supremes are now known as Diana Ross and the Supremes, likewise Martha Reeves and the Vandellas.

Saw Zally of the LOVIN SPOONFUL the other day, he was in Detroit for a one day promo trip for his new single effort "AS LONG AS YOU'RE HERE" could be another, especially since Zal is the most delightful nut around.

Speaking about another single performer with a big group, Frankie Valli and the Four Seasons make the scene at Masonic Aud. in Detroit on Sunday, October 8. As always, if the time and the bread are available, don't miss this great group....always a great show.

SCATTERED TIDBITS......Local and talented gal Kris Peterson has been signed by Capitol Records (Beatles, Beachboys, Nancy Wilson, etc.) should be the break she needs to show her talent.......The Parliments new sound "ALL YOUR GOODIES ARE GONE" could be bigger than "I WANNA TESTIFY" over a half-million in sales.

Nancy Sinatra doing her first TV special on NBC-tv on November 11th at 8 p.m. Her guests? Frank Sinatra and Dean Martin, what then?.....Englebert Humperdink (there's that name again) has the number one record in England called "THE LAST WALTZ" expected to match its position here in the states.

A quick note on behalf of the Big 8 Jocks to say thanks to you, our listeners and supporters for making station CKLW the number one rated pop-music station in Detroit,

Young Adult—TOP TEN

1. To Sir With Love-Lulu-Epic
2. Never My Love-Association-Warner
3. What Now My Love-Mitch Ryder-Dyno Voice
4. The Letter-Box Tops-Mala
5. Hey Baby-Buckinghams-Columbia
6. It Must Be Him-Vikki Carr-Liberty
7. Ode To Billy Joe-Bobbie Gentry-Capitol
8. Heavy Music-Bob Seger-Cameo
9. If This Is Love-Precisions-Drew
10. I Make A Fool Of Myself-Frankie Valli-Philips

The *Young Adult* newspaper was published in 1967 by coauthor Bob Harris. With a circulation of 5,000, this weekly was passed from teen to teen, years before the Internet. This page from October 5, 1967, lists all the hot teen dance clubs in the greater Detroit area. A column by CKLW disc jockey Tom Shannon shows the cross media promotion that helped propel rock and roll. Shannon's column was local information, gossip, and insights, such as, "Will Success Spoil? The Supremes are now known as Diana Ross and The Supremes." Shannon was one of the big voices of rock and roll.

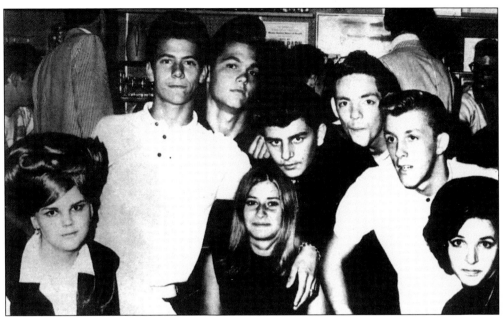

There were two Chatterbox teen clubs in the 1960s, one in Allen Park and one in Warren, Michigan. This photograph from the *Set* newspaper shows teens having a good time at the Allen Park Chatterbox, hopefully enticing other teens to come to the Chatterbox for a good time. This club, and others like it, did not serve alcohol, but they did serve exotic drinks. The menu below is from the Chatterbox in Warren. These drinks had umbrellas, cherries, and colored juices aimed at simulating the real thing. Drink choices included Stingers, Screwdrivers, Zombies, and Weirdos. The *Set* newspaper was published for three months and then was gone.

```
        THE   CHATTER   BOX                        (ALL DRINKS LISTED ARE NON-ALCOHOLIC)

                                              WIERDO . . . . . . . . . . . . . . . . . . 50
751 E. 13 Mile Road              Phone
Warren, Michigan              264-9815         PINK LADY. . . . . . . . . . . . . . . . . 50

  MICHIGAN'S FINEST YOUNG ADULT NIGHT CLUBS    LATIN DAIQUIRI . . . . . . . . . . . . . . 45

     ↟↟↟↟↟↟↟↟   Featuring   ↟↟↟↟↟↟↟↟           PINK PANTHER . . . . . . . . . . . . . . . 45

VE ENTERTAINMENT - DANCING - EXOTIC SOFT DRINKS CREME DE COCOA . . . . . . . . . . . . . . 40

                   OPEN                        CREME DE MINT. . . . . . . . . . . . . . . 40

   THURSDAY - FRIDAY - SATURDAY - SUNDAY       WINE COLLINS . . . . . . . . . . . . . . . 40
             8:00 PM til 12:30 AM
                                              LEMON PASSION. . . . . . . . . . . . . . . 40
       COVER CHARGE..$1.25
      includes tax  and checking               SWEET-N-SOUR . . . . . . . . . . . . . . . 40

       CONTINUOUS   ENTERTAINMENT              ZOMBIE . . . . . . . . . . . . . . . . . . 40

   MUSIC STARTS AT 8:00 AND ENDS AT 12:00 AM   STINGER. . . . . . . . . . . . . . . . . . 40
      Juke box dancing till closing.
                                              LEMON COOLER . . . . . . . . . . . . . . . 40

                                              SCREWDRIVER. . . . . . . . . . . . . . . . 35
     YOU MUST BE 17 YEARS OF AGE OR OLDER
            TO GAIN ADMITTANCE TO              RUM & COKE . . . . . . . . . . . . . . . . 35
   THE CHATTER BOX YOUNG ADULT NIGHT CLUB
                                              CHERRY COKE. . . . . . . . . . . . . . . . 30

       YOUR HOSTS - JERRY AND REGGIE           CHERRY SPRITE. . . . . . . . . . . . . . . 30

                                              COKE SOUR. . . . . . . . . . . . . . . . . 30

                                                       ---PLAIN STUFF---

                                              COKE . . . . . . . . . . . . . . . . . . . 25
                 Chatter Box East
                 5751 E. 13 Mile Rd.          SPRITE . . . . . . . . . . . . . . . . . . 25
                 Warren, Michigan
                                                    -----GOODIES-----
```

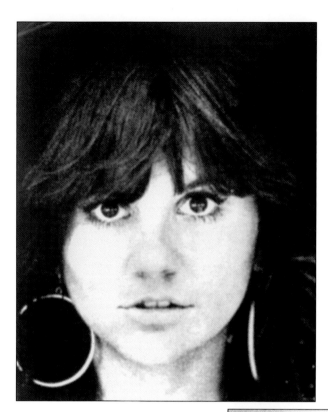

Linda Ronstadt was born in Tucson in 1946, to Ruth Mary, who was raised in Michigan. In high school, Ronstadt, her brother, and her sister started a folk trio called the Three Ronstadts. In 1964, she moved to Los Angeles and formed the Stone Poneys. In 1968, she went solo. In 1971, she performed with a backup band that included Don Henley, Glenn Frey, Randy Meisner, and Bernie Leadon. This group later became the Eagles. Between 1967 and 1990, Ronstadt had 34 top 100 hits. "You're No Good," "When Will I Be Loved," and "Blue Bayou" are some of her biggest hits. This is a 1968-era Capitol Records photograph.

Janis Joplin was born in Port Arthur, Texas, in 1943. She died too young, in 1970 at 27 years. Nicknamed "Pearl," she moved to San Francisco in 1966 where she emerged as the wailing lead singer of Big Brother and The Holding Company. Her first top 100 hit, "Piece of My Heart," was released in 1968. That year, "Down on Me" showed anyone who doubted that Joplin was a unique talent. In 1968, Joplin is photographed as she arrives at Detroit Metro Airport, bundled up, ready for the cold weather. She was inducted into the Rock and Roll Hall of Fame in 1995. (Leni Sinclair.)

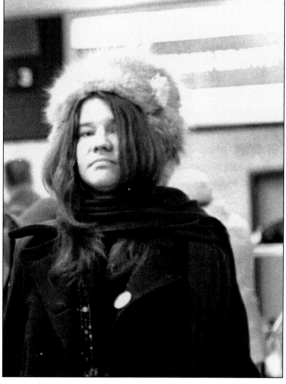

The Mamas and the Papas were formed when Dennis Doherty (1941); John Phillips (1935) from the Journeymen; Holly Michelle Gilliam (1945), John's wife since 1962; and Ellen Naomi Cohen (Cass Elliott, 1941) came together in 1964. In 1965, Detroit's WKNR ranked the group's "Creeque Alley" at No. 15. Cass's wailing vocals on "Dream a Little Dream of Me" in 1968, followed the 1966 hits "California Dreaming," "Monday, Monday," and "Words of Love." Between Cass Elliott and the Mamas and the Papas, they had 23 top 100 hits before Cass's death in 1974. John Phillips died in 2001.

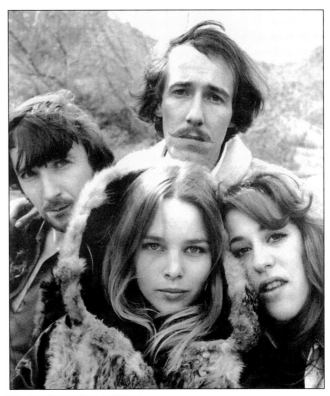

Bob Seger continues to rock. Born in Dearborn, Michigan, in 1945, this singer, songwriter, and guitarist, first recorded in 1967, and in 1968, he formed the System. In 1970, he formed the Silver Bullet Band. His biggest hits are "Shakedown," "Shame on the Moon," "Night Moves," and "Against the Wind." Between 1968 and 1991, Seger released 32 top 100 hits. After a long absence, Seger released a new album in 2007. (Leni Sinclair.)

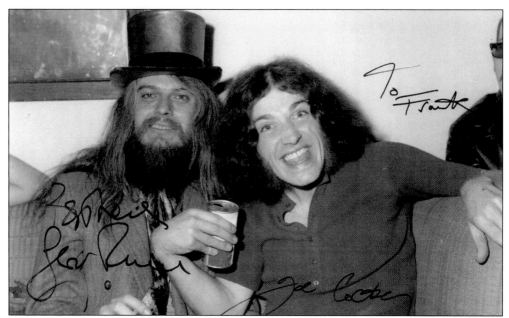

Party animals Leon Russell (1942) and Joe Cocker (1944) were photographed at Detroit's Eastown Theatre in 1970 by rock photographer Frank Pettis. Russell, born Claude Russell Bridges, recorded his first top 100 hit in 1976. He and England's Cocker became great friends and collaborated on a number of projects, including Cocker's hit, "The Letter," in 1976. Cocker's career took off after his breakout Woodstock performance in 1969. Between 1968 and 1990, Cocker released 22 top 100 hits.

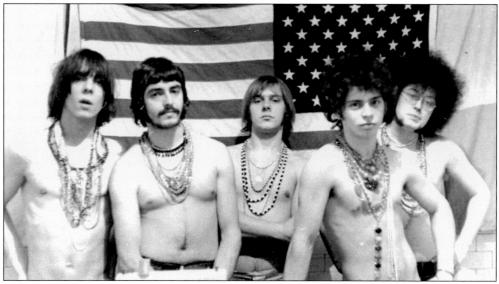

MC5, short for Motor City 5, was a hard-rock band formed in Detroit, in 1963. Rob Tyner (vocals), Wayne Kramer and Fred "Sonic" Smith (guitars), Michael Davis (bass), and Dennis Thompson (drums), hit the rock scene hard. They even converted antirocker John Sinclair to the cause. Sinclair even became their manager. Although they only had one top 100 hit, "Kick Out the Jams" (1969), their local influence was profound. Tyner died in 1991 and Smith in 1994. (Leni Sinclair.)

In this 1969 Led Zeppelin photograph, taken at Detroit's Olympia Stadium, Robert Plant sings while Jimmy Page uses a violin bow to play his guitar. Their biggest hit, "Whole Lotta Love," was released in 1969. Their most famous recording, "Stairway to Heaven," was never released as a single. The group's first nine albums sold over 88 million copies. In 1995, they were inducted into the Rock and Roll Hall of Fame. (Photograph by Charles Auringer, courtesy of Ray Goodman.)

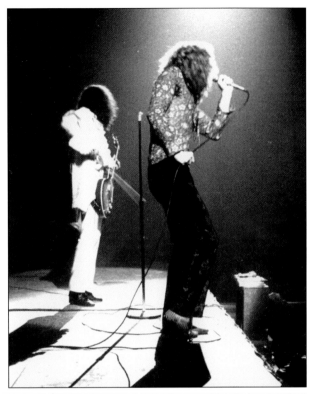

Salem Witchcraft formed in Detroit in 1969 with Mark Derrick (vocals), Dennis Lasarski (guitar), and Bob Counters (drums). They played in various incarnations through the 1970s. Although this group never had a top 100 hit, they had a legion of local fans. Their debut single was "Just Looking." They played the best local clubs but never had that breakout hit. (Frank Pettis.)

The Flaming Ember was formed by Joe Sladich (guitar), Bill Ellis (piano), Jim Bugnel (bass), and Jerry Plunk (lead vocalist and drummer). Formed in 1963–1964, and originally named the Flaming Embers, after the well-known downtown Detroit restaurant, they were the Flaming Ember when their first top 100 hit, "Mind, Body and Soul," released in 1969. Their biggest hit, "Westbound #9," was released in 1970. During their two years of recording, they had four top 100 hits.

Blood, Sweat and Tears was formed by Al Kooper (keyboardist) in 1967. This rock-jazz group's core members included, Kooper (1944), Steve Katz (1945), Bobby Colomby (1944), and Jim Fielder (1947). The group's first top 100 hit, "You've Made Me So Very Happy," was released in 1969. That same year, they scored two additional top 100 hits with "Spinning Wheel," and "And When I Die." Sometimes they played with major American symphonies, including the Detroit Symphony Orchestra.

Three

MOTOWN

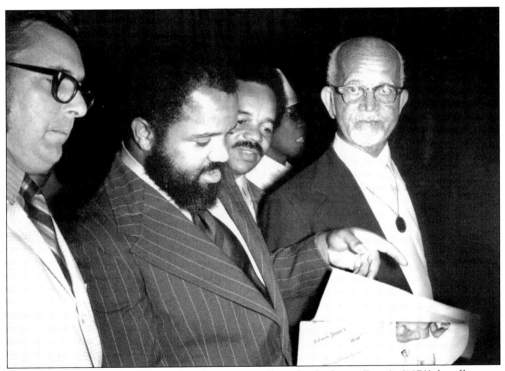

For Motown's Berry Gordy, no detail is too small, as he looks at *Extra*'s (1970) headline on Motown singer Edwin Starr and his new hit "War." Coauthor Bob Harris, publisher of *Extra*, looks from the left. To the right of Gordy are his brother Fuller and his father, "Pops" Gordy. Berry Gordy is a world-class songwriter, businessman, musician, detailist, founder, and visionary. In 1988, Berry was inducted into the Rock and Roll Hall of Fame.

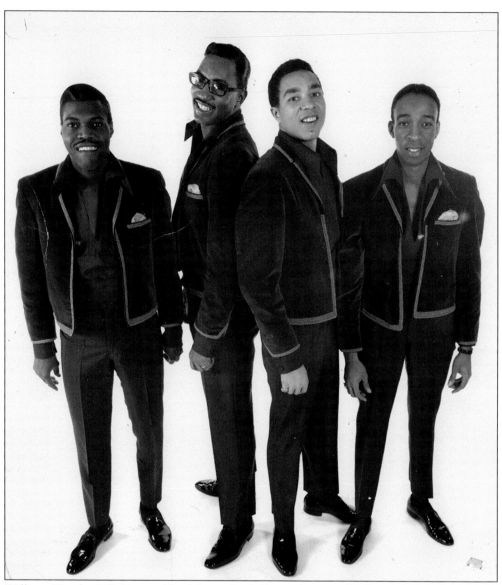

William "Smokey" Robinson (third from the left) was born in Detroit in 1940. Songwriter, singer, corporate executive, and creative legend, Robinson was a key to Motown's quality and success. Bob Dylan called Robinson one of America's greatest living poets. Robinson formed his original group, the Matadors, at Northern High School in Detroit. He was married to group member Claudette Rogers from 1958 to 1986, and in 1958, on his 18th birthday, his group's first record was released. The group, now called the Miracles, included Robinson, Claudette, Bobby Rogers, Ronnie White, and Warren Moore. All of the 48 top 100 hits they released between 1960 ("Shop Around," Motown's first million record seller) and 1975 ("Love Machine") were released on Motown's Tamla label. Between 1961 and 1969, Robinson wrote or cowrote 43 songs that made the top 40 charts. Robinson left the group and went solo in 1977, and between 1973 and 1991, he released 25 top 100 hits. He was inducted into the Rock and Roll Hall of Fame in 1987. Both the Miracles and Robinson continue to perform. This 1965-era photograph is from the collection of Bob Harris.

Hitsville U.S.A. is the little house at 2648 West Grand Boulevard in Detroit where the Motown sound was born, played, and recorded. The garage, at the back of the house, was converted into the now famous Studio A of Motown Records in 1959. Berry Gordy and his family lived upstairs, his offices were on the first floor, in the front. An engineering booth looked into Studio A. Except for early work, almost all Motown hits were recorded in this building. It was called Hitsville, because this was where the hits came from. This little house, a national gem, lives today, totally intact and restored to its 1960s condition, as the Motown Historical Museum. Thanks to the vision of Esther Gordy Edwards, former Motown vice president, museum founder, and sister of Berry, the physical legacy of the Motown companies has been preserved. Through the efforts of this great lady, committed friends, volunteers, employees, and the always-loyal Motown alumni, the fun, business, and living quarters and Studio A of Motown can be experienced everyday by Motown fans. (Motown Historical Museum.)

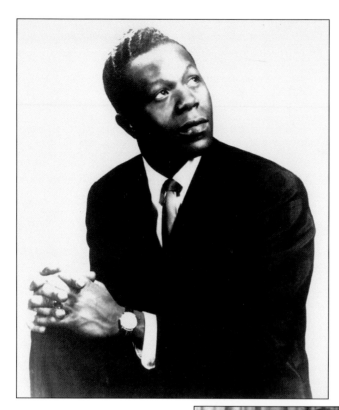

Marv Johnson was born in Detroit in 1938. This singer, songwriter, and producer joined the Serenaders in the mid-1950s. At the same time, Berry Gordy was writing songs for Jackie Wilson. As songwriters, the two cowrote "Come to Me." The Ber-Berry Co-op, a Gordy family savings club, loaned Gordy the money to record Johnson singing "Come to Me," Motown's first record and hit. Johnson's contributions to Motown, and its founding, are widely recognized. Later he worked in sales and promotions for Motown. Johnson died in 1993 at 54 years. (Frank Pettis.)

The Joe Hunter Band did backing music for scores of Motown hits, often working with Earl Van Dyke (piano) and Robert White. This group of musicians, some coming and going, called themselves the Funk Brothers. Key members included Uriel Jones and Richard "Pistol" Allen (drums) and percussionists Eddie "Bongo" Brown, Jack Ashford, and Jack Brokensha. Members of the Joe Hunter Band here are, from left to right, (first row) Benny Benjamin, Larry Veeder, and Mike Terry; (second row) James Jamerson and Hank Cosby; and (third row) Joe Hunter. (Motown Historical Museum.)

Mary Wells was born in Detroit in 1943 and became a major Motown talent. At 17, she showed Gordy a song, "Bye Bye Baby," that she had written for Jackie Wilson. Gordy signed her to his Motown label, and Wells's recording of that song went to No. 1. She was the first Motown artist to have a No. 1 hit. "My Guy" went to No. 1 in 1964. Between 1961 and 1968, she had 23 top 100 hits. Wells died in 1992. (Motown Historical Museum.)

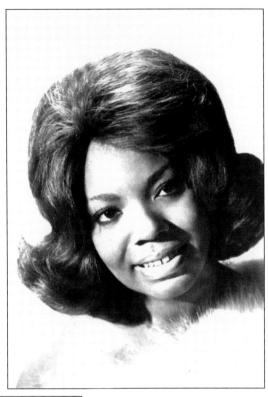

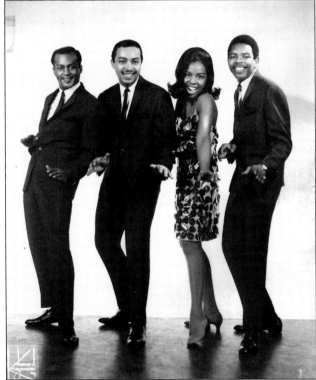

Gladys Knight was eight years old when she became the lead singer of her Atlanta family's rhythm-and-blues group in 1952. The Pips were named after cousin James "Pip" Woods, their manager, and included Gladys's brother Merald "Bubba" Knight and cousins Edward Patton and Langston George. Their first top 100 hit, "Every Beat of My Heart," was released in 1961. Their first No. 1 hit, "Midnight Train to Georgia," was released in 1973. Between 1961 and 1980, they released 38 top 100 hits. Gladys still performs. (James Kriegsmann.)

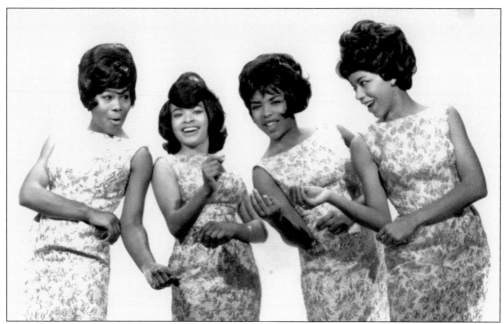

The Marvelettes were originally a quintet, but Juanita Cowart (not pictured) left in 1962, after the group had its first hit, "Please, Mr. Postman," in late 1961. This song became the first No. 1 hit by a Motown group. "Playboy" (1962) and "Don't Mess with Bill" (1966) were also big hits for the group. The original Marvelettes seen here are Gladys Horton, Georgeanna Marie Tillman Gordon, Wanda Young, and Katherine Anderson. (Motown Historical Museum.)

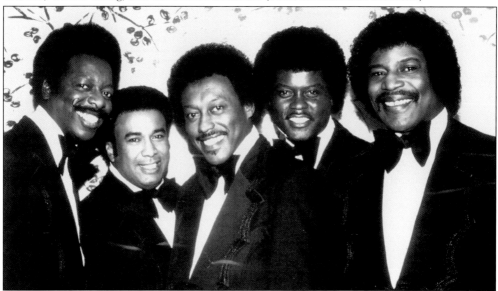

The Spinners, from Detroit, began life as the Domingoes. Harvey Fuqua of the Moonglows discovered them in 1961 and signed them to the Tri-Phi label that he co-owned with Gwen Gordy. In 1963, they moved to Motown. They had one hit, "Together We Can Make Such Sweet Music," in 1973. In 1972, the group included Philippe Wynne, tenor (1941); Bobby Smith, tenor (1946); Billy Henderson, tenor (1939); Henry Frambrough, baritone (1935); and Pervis Jackson, bass (1938). (Gary Spicer.)

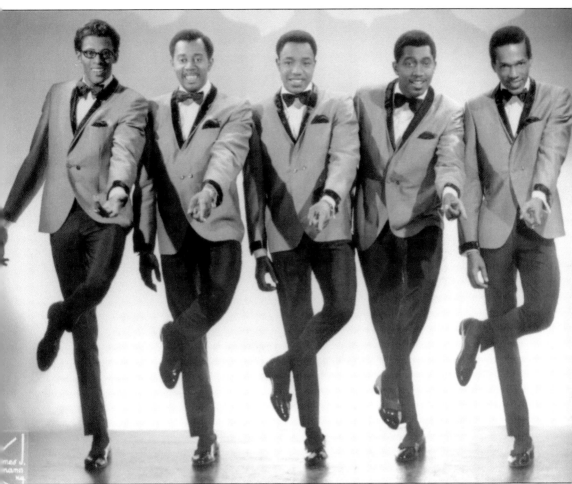

The Temptations came to Detroit from the South and rose to international stardom. The original group had Eddie Kendricks (1939), Paul Williams (1939), Melvin Franklin (1942), Otis Williams (1941), and Elbridge Bryant. Bryant was replaced by David Ruffin (1941, far left in photograph). Originally called the Primes when they signed with Motown in 1961, they became the Elgins. By 1963, they were the Temptations when their first top 100 hit, "The Way You Do the Things You Do," was released in 1964. In 1965, "My Girl," their first of four No. 1 top 100 hits, was released. Many personnel changes occurred over the years. Between 1964 and 1991, this group released 55 top 100 songs. In 1989, the Temptations were inducted into the Rock and Roll Hall of Fame. Original member Otis Williams's Temptations continue to perform before large audiences. (Photograph by James J. Kriegsman, courtesy of the Motown Historical Museum.)

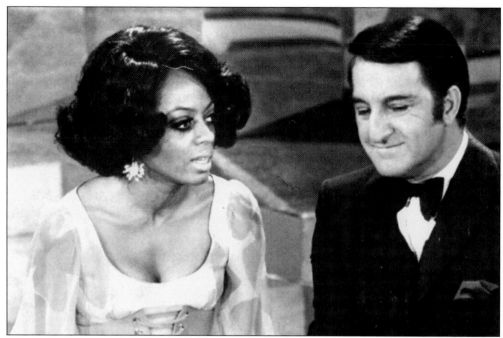

Diana Ross was born in Detroit in 1944 and first sang with the Primettes and then the Supremes (1961–1969). She left for a solo career in 1969. Between 1970 and 1986, she had 41 top 100 hits. "Ain't No Mountain High Enough," "Touch Me in the Morning" (the theme from *Mahogany*), "Love Hangover," and "Upside Down" all made it to No 1. Ross is pictured here with renowned Detroit area entertainer Danny Thomas, founder of St. Jude's Hospital.

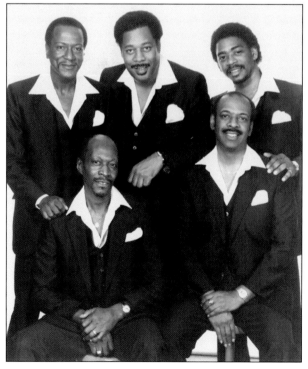

The Contours were one of the early groups to achieve success at Motown Records. This group of Detroiters included Billy Gordon, Bill Hoggs, Joe Billingslea, Sylvester Potts, Avey Dairs (died 2002), and Herbert Johnson (died 1980). Dennis Edwards, a member in 1967, joined the Temptations in 1968. The group's first top 100 hit, "Do You Love Me," written by Berry Gordy, was released in 1962 on Motown's Gordy label. Between 1962 and 1967, the Contours released eight top 100 hits. They still perform.

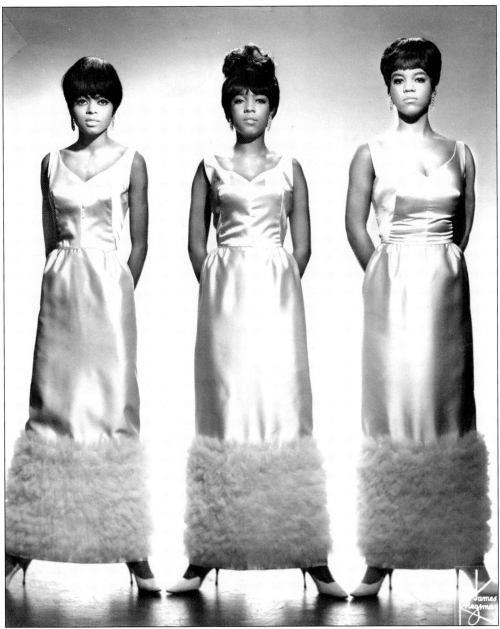

The Supremes, with Diana Ross (1944), Mary Wilson (1944), and Florence Ballard (1943), were all born in Detroit. Coming together as the Primettes in 1959, they signed with Motown's Tamla label in 1960. A year later, they became the Supremes. Although they recorded four top 100 hits between 1962 and 1964, their early role at Motown was to sing backing vocals. In July 1964, Motown released their first breakout No. 1 hit, "Where Did Our Love Go." Three months later, "Baby Love" became their second No. 1 hit. The following month they hit No. 1 again with "Come See About Me." Florence Ballard left the group in 1965 and was replaced by Cindy Birdsong. Diana Ross left in 1969 for a solo career that continues today. When Mary Wilson, the last original Supreme, left in 1976, the franchise folded. Between 1962 and 1976, the group had 45 top 100 hits. (James Kriegsmann.)

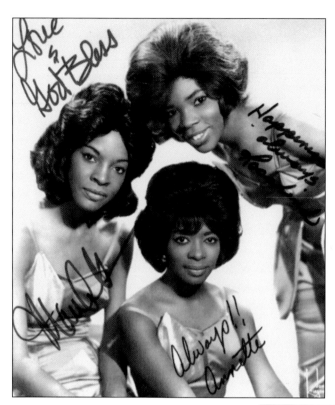

Martha Reeves (1941) and the Vandellas, Annette Beard and Rosalind Ashford, had their first major hits, "Heat Wave" and "Quicksand," in 1963. Beard left in 1963 and was replaced by Betty Kelly, formerly with the Velvelettes. In 1964, the group had its monster hit, "Dancing in the Street." Although Reeves still performs, her contributions and commitment to Detroit were recognized by voters, who elected her to Detroit's city council.

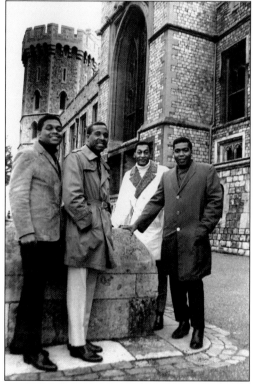

The Four Tops are vintage Motown. Formed around 1962, all of the original members grew up as friends in Detroit. Levi Stubbs (1936, the lead singer), Renaldo "Obie" Benson (1936), and Abdul "Duke" Fakir (1935), continue to perform today, often in double-bills with the Temptations. Between 1964 and 1972, the Four Tops had 30 top 100 hits on the Motown label. In 1966, they released their biggest hit, "Reach Out I'll Be There," which went to No. 1. In this 1966 photograph, the Four Tops pose during their 1966 tour of the British Isles. They were inducted into the Rock and Roll Hall of Fame in 1990.

This 1965 Motown concert poster invites people to the Bowen Field House, on the Eastern Michigan University campus, in Ypsilanti. For $2, one could hear six of the hottest groups and performers in the country. Also entertaining on that date are ventriloquist Willie Tyler, and his partner, Lester. Motown put on a complete show, here and across the country, day after day. Today these posters are rare and quite collectable. (From the collection of Glenn Silvenis.)

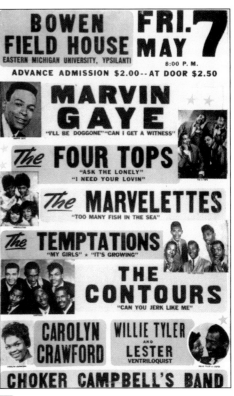

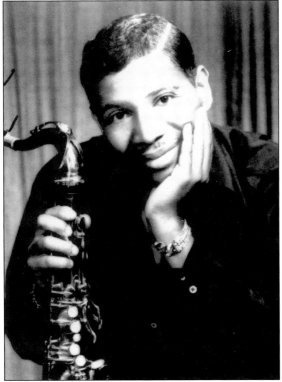

Junior Walker was born Autry Dewalt Walker, in Blythesville, Arkansas, in 1931. This singer, saxophonist, and songwriter, recorded two top 100 hits on Motown's Soul label between 1965 and 1972. His saxophone on his first and biggest hit, "Shotgun" (1965), wailed like no other. He wrote "Shotgun" for himself and his group, the All Stars. Berry Gordy produced the song. Walker played sax on Foreigner's 1981 hit "Urgent." Walker died in 1995, at 64 years. (Motown Historical Museum.)

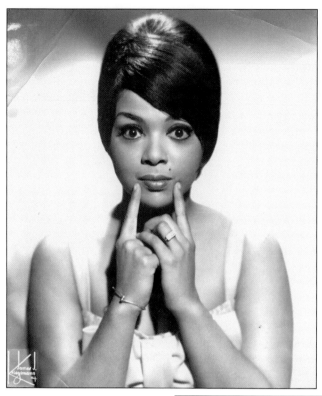

Tammi Terrell was born Tammy Montgomery in Philadelphia, in 1946. First singing with the James Brown Revue, she had her first top 100 hit, "I Cried," in 1963. By 1966, she was in Detroit recording on the Motown label. Her first hit was, "I Can't Believe You Love Me," in 1966. Her duet with Marvin Gaye, "Ain't No Mountain High Enough," was a major hit for the two in 1967. Tragically she died of a brain tumor on March 16, 1970. (Photograph by James J. Kriegsmann.)

Jimmy Ruffin was born in Collinsville, Mississippi, in 1939. His younger brother, David Ruffin (1941) became a lead singer with the original Temptations. Jimmy's first top 100 hit, "What Becomes of the Broken Hearted," was released on Motown's Soul label in 1966. It went to No. 7 and was his biggest hit. This photograph is from this period. During his prime career (1966–1971), Jimmy had seven top 100 hits. He hit again in 1981 with "Hold on to My Love." He cowrote and produced the song with his friend Robin Gibb. (Photograph by James J. Kriegsmann.)

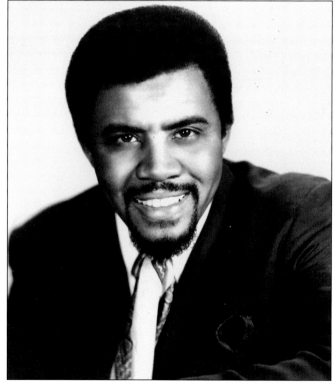

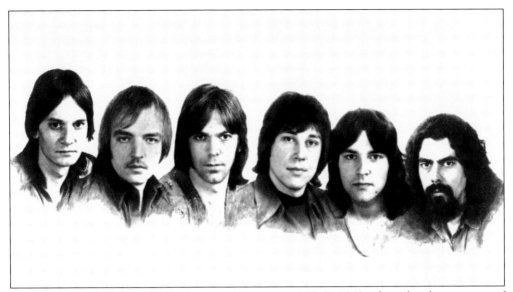

Rare Earth started life as the Sunliners in Detroit in 1966. In 1968, when they became one of the first white bands to sign with Motown, they signed with Motown's Rare Earth label after changing their name to the same. Members of Rare Earth included Pete Rivera, Gil Bridges, Ken James, John Parrish, Rod Richards, and Ed Guzman. As the Sunliners, they opened for the Beatles' 1966 Detroit appearance. Their biggest hit was their first, "Get Ready," released in 1970.

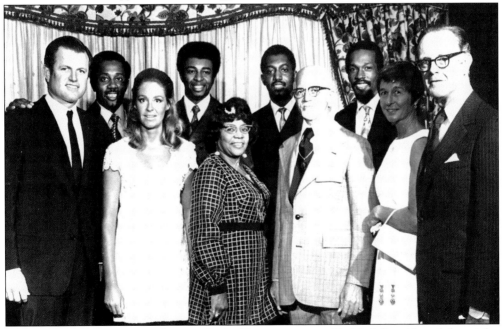

In this 1960s Motown power photograph, the Temptations stand behind, listed from left to right, U.S. Senator Ted Kennedy and his wife, Joan; Bertha and Berry "Pops" Gordy; and Jane and U.S. Senator Philip Hart. From the beginning, the outside world recognized that the Motown model was one of merit, diversity, achievement, quality, talent, drive, and star power. What more could one want for America? For these reasons, national and international leaders wanted to touch Motown.

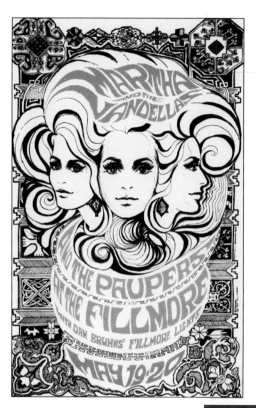

This 1967 psychedelic Fillmore West poster, featuring Motown's Martha and the Vandellas, was drawn by B. MacLean for concert impresario Bill Graham, to promote a San Francisco performance in May 1967. Psychedelic art came about the same time as LSD. Whatever the source, rock and this new art form created a mind-bending epoch.

James Jay (J. J.) Barnes was born in Detroit in 1943. As the lead singer with the Holidays, he scored his first top 100 hit, "Real Humdinger," on the Ric Tic label in 1966. Motown records bought Ric Tic records and Barnes, but never released anything of Barnes. Instead, Motown was interested in his songwriting skills. Motown's Martha and the Vandellas and the Marvelettes each recorded his work. Barnes still lives in Detroit.

Norman Whitfield and Barrett Strong came to Motown to write and produce. They did that, and how. During the turbulent 1960s, these men were social and political voices for Motown. In 1968, they wrote Marvin Gaye's "I Heard It through the Grapevine," and in 1970, they wrote and Whitfield produced, Edwin Starr's antiwar anthems. Over the years, Whitfield became one of Motown's most prolific producers. (Motown Historical Museum.)

Starr was born Charles Hatcher, in Nashville, Tennessee, in 1942. He first recorded in Detroit for the Ric Tic label, which was later purchased by Motown. Beginning in 1969, Starr was recording on Motown's Gordy label. When Starr's biggest hit, "War," went to No. 1 in 1970, the American antiwar movement seized Starr's song as its anthem. Starr released 14 top 100 hits between 1965 and 1979. Starr died in 2003 at 61 years. (Motown Historical Museum.)

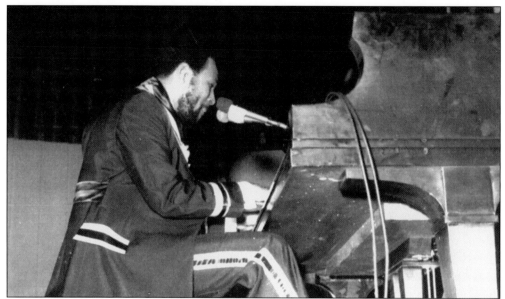

Marvin Gaye was born Marvin Pentz Gay Jr. on April 2, 1939, in Washington, D.C., where he sang in his father's church choir, as a child. He came to Detroit in 1960 and got work at Motown as a session drummer. His first No. 1 hit, "I Heard It through the Grapevine," was released in 1968. His next No. 1 hit, "Let's Get It On," was released in July 1973. Gaye had 56 top 100 releases. In this photograph, Gaye is playing a late 1960s concert in Detroit.

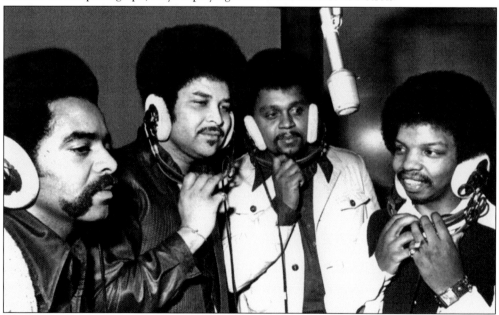

Although the Originals formed in 1966, each of the group's members had worked at Motown since its earliest days, singing backup for Marvin Gaye and Stevie Wonder. In this Studio A photograph (listed from left to right), Freddie Gorman (bass), Walter Gaines (baritone), and Henry Dixon (tenor), look at Cratham Spencer (tenor). They had their first of five top 100 hits, "Baby I'm for Real," released on Motown's Soul label, in 1969. They had their last hit, "Down to Love Town," on the same label, in 1976.

96

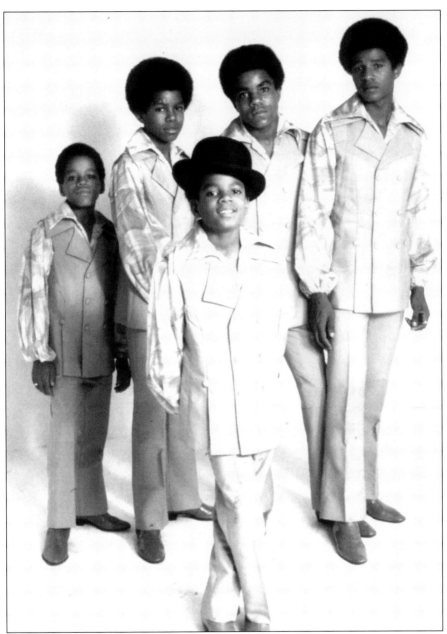

The Jackson Five, a quintet of brothers, was formed and managed by their father, Joe Jackson, in Gary, Indiana, in 1966. The brothers in the back are, from left to right, Marlon (1957), Jermaine (1954), Toriano "Tito" (1953), and Sigmund "Jacki" (1951), and in front is lead singer Michael (1958). Known as the Jackson Five from 1968 to 1975, the group lineup since 1989 has been Jackie, Tito, Jermaine, and Randy Jackson. They first recorded for the Steeltown label in 1968 but had their first top 100 hit in 1969 with "I Want You Back," on the Motown label. A year later they released "ABC," another No. 1 top 100 record. Michael's featured role led to the beginning of his solo career in 1971 at Motown. As the Jackson Five, they had 20 top 100 hits. Since 1975, the Jacksons have had 13 top 100 hits and were inducted into the Rock and Roll Hall of Fame in 1997.

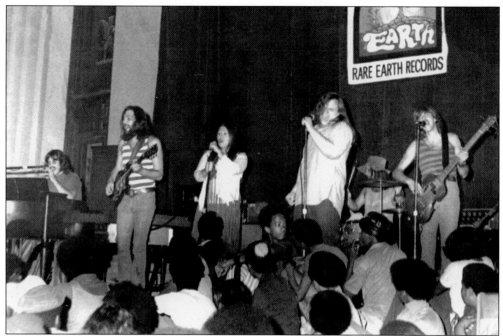

Cheryl "Stoney" Murphy, of Stoney and Meatloaf, was born in Detroit. Teamed with Meatloaf in 1971, they recorded their first top 100 hit, "What You See Is What You Get," on Motown's Rare Earth label. Meatloaf moved on and recorded 10 top 100 hits between 1971 and 1996. Meatloaf played "Eddie" in the movie the *Rocky Horror Picture Show*. This photograph shows (center) Stoney and Meatloaf at the microphones in this 1971 Detroit concert.

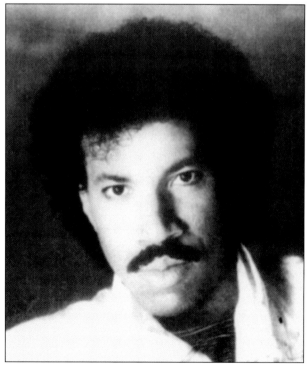

Lionel Richie (1949) first became a hit maker as a member of the Commodores, formed in Tuskegee, Alabama. Richie sang and played sax, William King (1949) played trumpet, Milan Williams (1948) played keyboards, Ronald LaPread (1950) played bass, and Walter "Clyde" Orange (1946) played drums. First recording for Motown in 1972, they had their first top 100 hit, "Machine Gun," in 1974. Their biggest hit, "Three Times A Lady," went to No. 1. A year later, "Still" went to No. 1. Between 1974 and 1986, the Commodores released 25 top 100 hits. (Gary Spicer.)

The Undisputed Truth was a Motown trio comprised of Joe Harris, Billie Calvin, and Brenda Evans. Motown's producer of socially relevant records, Norman Whitfield, put the group together in 1971, envisioning a cross between Sly Stone and the Fifth Dimension. The group's first top 100 hit, "Smiling Faces Sometimes," was released in 1971 on Motown's Gordy label. This song about deception and lies struck a chord in that Watergate era. Between 1971 and 1977, the Undisputed Truth released seven top 100 hits.

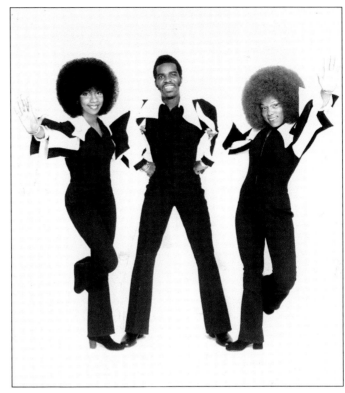

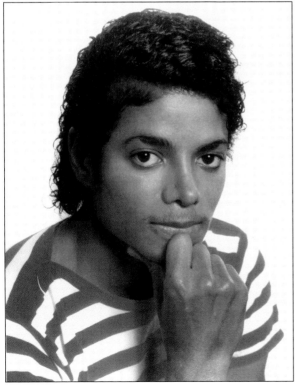

Michael Jackson was born in Gary, Indiana, in 1958. The stories of his father, brothers, and wives, have been told, yet no one can dispute that Motown's Jackson is a musical genius. Between his hits as lead of the Jackson 5, and as solo, Jackson has released over 75 top 100 hits. The Beatles released 73. Jackson, after years of absence, will return as a man with decades of genius yet to share. He was inducted into the Rock and Roll Hall of Fame, in 2001.

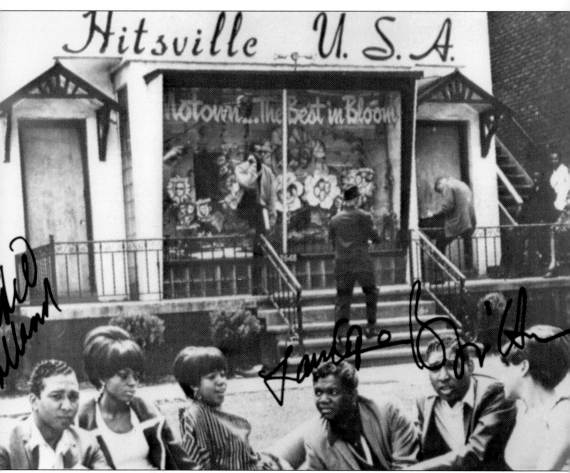

Detroiters Eddie Holland, Lamont Dozier, and Brian Holland (HDH) are songwriting and producing legends. Originally hired as singers by Berry Gordy in 1958, they became a songwriting team in 1962. The full creative genius of HDH exploded between 1965 and 1968. Always in writing competition with the brilliant Smokey Robinson, these men propelled Motown, and the groups they wrote for, into the stratosphere. HDH each also had management duties in the Motown structure. This 1965-era photograph shows HDH sitting with the Supremes in front of Hitsville U.S.A. In 1987, the National Academy of Songwriters' Lifetime Achievement Award was presented to HDH, and in 1988, they were inducted into the Songwriters Hall of Fame and won Grammy's Lifetime Achievement Award. (Shirley Washington.)

Four

THE BRITISH INVASION

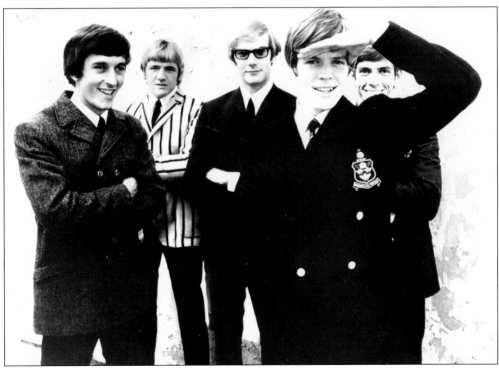

Herman's Hermits were part of the British invasion. Formed in Manchester, England, in the early 1960s, Peter "Herman" Noone sang vocals, Derek Leckenby and Keith Hopwood played guitar, Karl Green played bass, and Barry Whitwam played drums. Their first big hit, "(Baby, Baby) Can't You Hear My Heart Beat," was released in 1965. First playing Detroit in 1966, Noone left the group, going solo in 1972. He hosts music video shows on television channel VH-1 and performed as recently as July 2007 in the Detroit suburb of Novi.

Dusty Springfield was born Mary O'Brien in 1939 in London. With her brother Tom Springfield and Tim Field, they sang folk from 1960 to 1963 as the Springfields. Her first top 100 hit, "I Only Want to Be With You," was released in 1964. Dusty was instrumental in bringing Motown acts to England through her 1965 *The Sounds of Motown* television special. In this 1967 photograph, Dusty sings with composer-arranger Pete Rugolo.

The Dave Clark Five was part of the British invasion. Formed in Tottenham, England, in late 1960, by 1961 the band included Dave Clark, Mike Smith, Lenny Davidson, Denny Payton, and Rick Huxley. They appeared, for the first of 17 times, on the *Ed Sullivan Show*, in May 1964. In 1965, they had their one and only No. 1 hit, "Over and Over." In all, they recorded 24 top 100 hits. In this 1966 photograph, Clark (right) greets Detroit teen fans before the group's performance at Ford Auditorium. They were inducted into the Rock and Roll Hall of Fame in 2008.

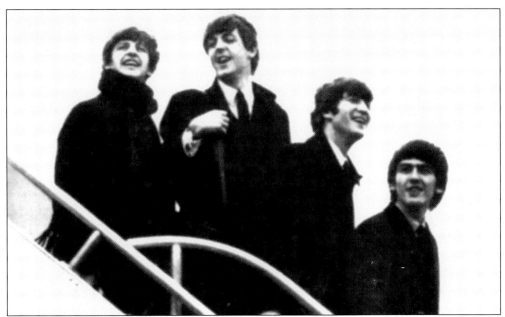

Ringo Starr (born Richard Starkey, 1940), Paul McCartney (1942), John Lennon (1940), and George Harrison (1943) landed in America in 1964, after forming in Liverpool, England, in the late 1950s. They first played Detroit on September 6, 1964. Promenade tickets cost $5. By all measures, the Beatles and Elvis lead all others in numbers of hits, No. 1 hits, albums, and money. With the passing of Lennon (1980) and Harrison (2001), McCartney and Starr continue to perform, separately, to sold-out stadium crowds. (T.C.G.)

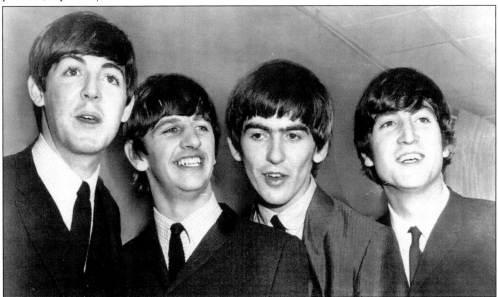

In 1964, Ed Sullivan broadcast the Beatles to America and the world. Their first top 100 hit, "I Want to Hold Your Hand," in 1964 went to No. 1. It would be the first of 20 No. 1 hits. Elvis had 19. The brilliance of the Beatles was clear, even to the few remaining doubters, when they released their *Sgt. Pepper's Lonely Hearts Club Band* album in 1967. Detroit's great Olympia Stadium hosted the Beatles' first Detroit appearance on that September 6, 1964. (Frank Pettis.)

Tom Jones was born in Pontypridd, South Wales, in June 1940. Originally named Thomas Jones Woodward, he worked local clubs in South Wales as Tommy Scott. In 1964, he moved to London and began his solo career. His first top 100 recording, "It's Not Unusual," was released in 1965. That same year he released "What's New Pussycat?" He also recorded "Thunderball," the title song to the James Bond movie, in 1965. In this photograph, Jones sings at the Michigan State Fair in the early 1970s. This photograph was published in coauthor Bob Harris's *Teen News* in 1966.

Alf Bicknell was not a rock star. Bicknell was one of the unseen rock concert workers who are part of rock concert extravaganzas. Living in Detroit until his recent death, Bicknell traveled with the Beatles in the 1960s as security. In this photograph, George Harrison continues to play as Bicknell carries a young female fan off the stage at this August 31, 1965, concert at the Cow Palace. (Amy Strong.)

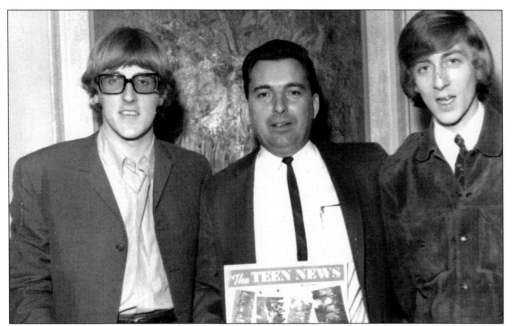

Chad and Jeremy flank coauthor Bob Harris holding a copy of the *Teen News* in this 1966 photograph. Formed in the early 1960s, this soft-rock duo from London came to America as part of the British invasion. Chad Stuart (1943) and Jeremy Clyde (1944) had their first hit, "Yesterday's Gone," in 1964. Three months later they hit again with their biggest song, "A Summer Song," which stayed on the charts for 14 weeks.

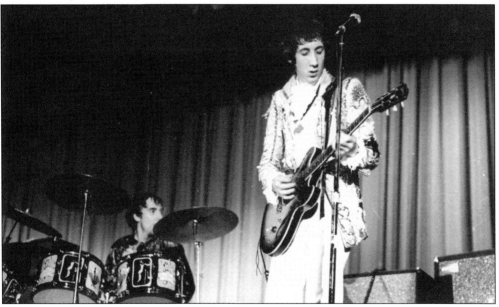

The Who was formed in London in 1964 by Roger Daltry, Pete Townsend, John Entwistle, and Keith Moon. Known for smashing their instruments at their act's climax, their most important contribution to rock and roll has been the rock opera. Although earlier artists had theme albums, the Who's rock opera "Tommy" was a first. Professional photographer Leni Sinclair took this photograph of the Who when they played at Southfield (Michigan) High School in 1967.

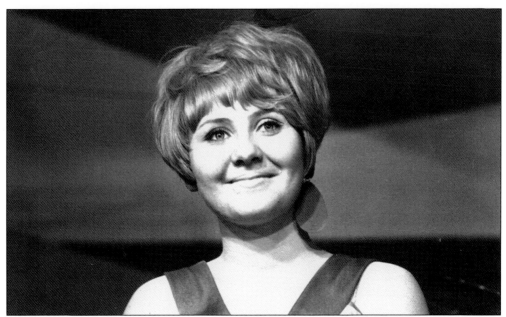

Lulu was born Marie Lawrie in 1948, near Glasgow, Scotland. Her biggest hit, "To Sir with Love," was the title song to the Sidney Poitier movie of the same name. On October 5, 1967, Detroit's young adult newspaper ranked this hit No. 1 in Detroit. Released in 1967, this song went to No. 1. Married to Barry Gibb of the Bee Gees in 1967, Lulu hosted her own television show in 1968 in England. Divorced in 1973, she made her last hit, "If I Were You," in 1981.

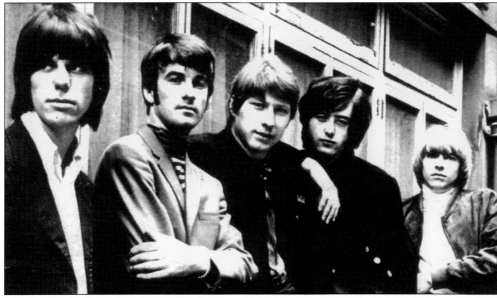

The Yardbirds, formed in Surrey, England, in 1964, became a legend. Although the group had nine top 100 hits between 1965 and 1967, the group's legend came as a spawning ground for rock greats. Eric Clapton joined the group in 1963. Jeff Beck replaced Clapton in 1965. Jimmy Page joined in 1966. The group disbanded in 1968. Later in 1968, Page formed a New Yardbirds that evolved into Led Zeppelin. A re-formed Yardbirds played Detroit's Magie Bag club in 2003. The group included Detroit bassist John Idan.

Rod Stewart was born in London in 1945. A singer and a songwriter, he first recorded in 1964. He joined a reconstituted Small Faces in 1969. This group had five top 100 hits between 1967 and 1973. His solo career began in 1971, with his No. 1 hit, "Maggie May." Between 1971 and 1998, Stewart recorded 54 top 100 hits. In this Small Faces–era photograph (1970), from left to right, Stewart, Detroit photographer Frank Pettis, and Ron Wood mug for a friend's camera. (Frank Pettis.)

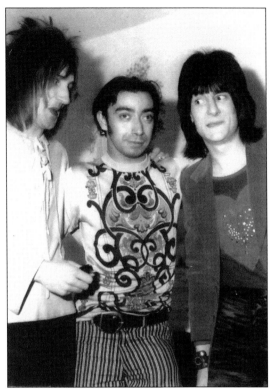

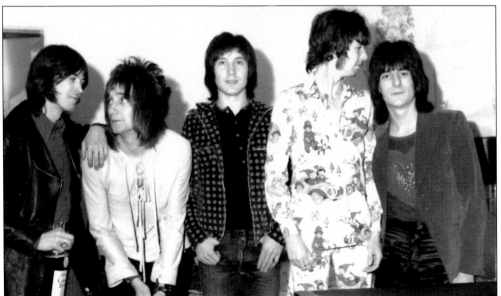

Small Faces formed in London in 1967. The group, reorganized in 1969 with (seen here from left to right) Ian McLogan, Rod Stewart, Kenny Jones, Ronnie Lane, and Ron Wood (later to join the Rolling Stones in 1976), recorded for six years, three as Small Faces and three as Faces. This photograph of Small Faces is from an album poster photograph shoot in 1970. After playing Detroit several times during their first U.S. tour in 1970, Stewart declared the band "made in Detroit." (Frank Pettis.)

David Bowie was born David Robert Jones, in London in 1947. He recorded with the King Bees, Manish Boys, and the Lower Third between 1964 and 1967. In 1967, he joined the Lindsay Kemp Mime Troupe. Maybe because of his mime experience, he adopted three personas during this period, Ziggy Stardust being the best known. He was married to Angie Barnett between 1970 and 1980. She's the Angie of Rolling Stones fame. Bowie wrote "Panic in Detroit," based on Iggy Pop's descriptions of revolutionaries that he had known as a youth in Michigan. He was inducted into the Rock and Roll Hall of Fame in 1996.

Olivia Newton-John was born in Cambridge, England, in 1948, and raised in Melbourne. At 16 years, she won a talent contest that returned her to England. Between 1971 and 1998, she released 41 top 100 hits. Her No. 1 hits included "I Honestly Love You," "Have You Never Been Mellow," and a duet with John Travolta, "You're the One that I Want." In 1984, she opened a chain of clothing boutiques called Koala Blue, and in 1999, Newton-John performed at Detroit's Pine Knob Theater. (Frank Pettis.)

Sir Elton John was born Reginald Kenneth Dwight in Middlesex, England, in 1947. He took the Elton John name by combining the first names of two early band mates, Elton Dean and John Baldry. John is pictured here with Ray Cooper, percussionist on John's early recordings. In 1973, "Crocodile Rock" became his first No. 1 hit. His plan to collaborate with Detroit's Eminem was cancelled, after the rapper Proof was shot dead in a Detroit nightclub, in 2006. (Charlie Davis.)

Uriah Heep, a hard-rock group, came from England in 1972. David Byron sang, Mick Box played lead guitar, Ken Hensley played keyboards, Gary Thain played bass, and Keith Baker played drums. They first played Detroit on January 19, 1972. Their first top 100 hit, "Easy Livin'," was released in 1972. Thain died at 27 years in 1976, and Byron died at 38 years in 1985. Their final top 100 hit, "Stealin'," was released in 1973.

Bad Company came to America from England in 1974. Pictured here are, from left to right, Raymond "Boz" Burrell (1946, bass), Paul Rodgers (1949, lead singer), Mick Ralphs (1944, guitar), and Simon Kirke (1949, drums). Their first top 100 hit, "Can't Get Enough," was also their biggest hit. A year later in 1975, they released "Feel Like Makin' Love." Bad Company recorded 10 top 100 hits. Although small in number, their Detroit fans were committed.

Pink Floyd formed in England in the 1960s, but they did not have a top 100 hit until "Money" in 1973. They first performed in Detroit in April 1972 at Ford Auditorium. They did their best work on albums, releasing five No. 1 albums between 1973 and 1995. They took their name from Georgia bluesmen Pink Anderson and Floyd Council. Their album *Dark Side of the Moon* was on the charts for 741 weeks. (Frank Pettis.)

Five

THE 1970S

Jerry Garcia was born in 1942. In the Grateful Dead, Garcia and Bob Weir (1947) sang and played guitar, Ron "Pigpen" McKernan played organ and harmonica, Phil Lesh played bass, and Bill Kreutzman played drums. Their first top 100 hit, "Uncle John's Band," was released in 1970. The group only had eight top 100 hits and no No. 1 hits, but the legend is bigger than the resume. In a 1985 *Detroit Free Press* interview, Garcia admitted that the group's lack of commercial success was "of some concern to us."

Three Ounces of Love—Elaine (September 10, 1956), Ann (July 14, 1955), and Regina Alexander (September 18, 1957)—was a west side Detroit sisters group managed by coauthor Bob Harris in the early 1970s. They were the opening act for the Commodores's 1978 national tour. While in Detroit, the sisters performed at a number of local venues including the 20 Grand, Mr. Kelly's Lounge, and the Dearborn Townhouse. They sang the national anthem at Tiger Stadium to appreciative fans on several occasions.

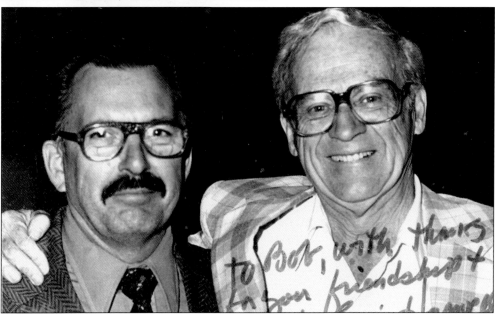

Why is Ernie Harwell in a rock-and-roll book? Most people know Harwell as the "Voice of the Tigers" for 31 years and for his community work. Few know that Harwell is a songwriter. He and Chuck Boris wrote "Why Did It Take You So Long?" in 1970 for Three Ounces of Love, a group managed by his friend and coauthor Bob Harris. Three Ounces of Love did not record the song. Harwell's work in many fields has made him a legend.

Detroit superstar disc jockey Ernie Durham (striped suit, second row), was born in New York City. In the late 1950s, he was hired by WBBC in Flint, Michigan. His popularity and his commitment to rock and roll soared. Soon he was doing a night show on Detroit's WJLB-AM. His record hops and remote broadcasts from Detroit's famous Graystone Ballroom and the Twenty-Grand are legend. In this 1971 photograph, the Staple Singers sit, while their dad stands to the far left. Durham died in 1992. The Staple Singers were a family group. Seen here from left to right, Roebuck "Pop" Staples (1915), and daughters, Mavis (1940, lead), Yvonne (1943), and Cleotha, are in Detroit in 1971 for a benefit. They had their first top 100 hit in 1967. In 1971 and 1975, they released two No. 1 hits, "I'll Take You There," and "Let's Do It Again." Mavis began a solo career in 1970. They were inducted into the Rock and Roll Hall of Fame in 1999. Pop died in 2000, at 84 years. (Frank Pettis.)

Freda Payne was born in Detroit in 1945. She moved to New York City and performed with Pearl Bailey, Duke Ellington, and Quincy Jones. Her first top 100 hit, "Band of Gold," written by Holland-Dozier-Holland (HDH), was released in 1970. Between 1970 and 1972, she had six top 100 hits. In this photograph, Payne was between performances at the Michigan State Fair in 1972. A lemonade stand is visible in the background. Her sister Scherrie Payne performed as one of the later Supremes.

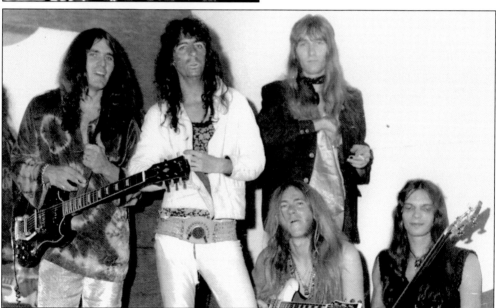

Alice Cooper (second from left) was born Vincent Furnier in Detroit in 1948. The Alice Cooper band was formed in 1965. Pictured in this 1970 photograph, taken by rock photographer Frank Pettis at the Factory Ballroom, in Waterford, Michigan, are, from left to right, Michael Bruce (keyboards), Furnier (vocals), Glen Buxton (guitar), and Dennis Dunaway (bass), and in back, Neal Smith (drums). Between 1971 and 1991, Alice Cooper released 21 top 100 hits. Their biggest hit, "School's Out," was released in 1972. The band split in 1974.

Dennis Niemiec worked as a reporter and newspaper writer during the mid-1970s, when this photograph was taken. He was an award-winning reporter for the *Detroit Free Press*. Niemiec and news writers at the *Michigan Chronicle*, the *Detroit News*, and newsprint publishers across the country, carried the advertisements for concerts, stories about musicians and bands, and helped spread the word of rock. Niemiec is currently deputy director of communications for Michigan's Wayne County government.

The Circle's band members are photographed standing on the roof of Gabriel's Horn, a local bar on Ford Road in Detroit suburb Garden City, in this 1972 photograph. Many local bands played at Gabriel's Horn. In the late 1970s, the name of Gabriel's Horn was changed to the Affair Lounge. Next sold to Jamie Coe, of Jamie Coe and the Gigolos, Coe ran this lounge until his death from a heart attack in 2007 at 71 years. During his performing days, Coe was managed by Bobby Darin.

Edgar Winter was born in Beaumont, Texas, in 1946 and formed his group in 1970. This singer, saxophonist, and keyboardist's group included Dan Hartman, Ronnie Montrose, and Rick Zehringer. His first hit, "Keep Playin' that Rock 'n' Roll," was released in 1971. Winter and his group played Detroit's Masonic Auditorium. "Frankenstein," his only No. 1 top 100 hit, was released in 1973. Zehringer was the former lead singer and guitarist with the McCoys, whose hit "Hang On Sloopy" went to No. 1 in 1965. (Frank Pettis.)

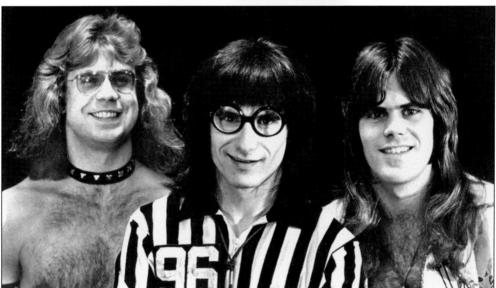

Brownsville Station, a rock trio, came out of Ann Arbor in the early 1970s. Michael Lutz sang lead and played bass, Michael "Cub" Koda played guitar, and Henry Weck played drums. Their first top 100 hit, "The Red Back Spider," was released in 1972. Their biggest hit, "Smokin' in the Boy's Room," was released in 1973. When they made their last top 100 hit, "The Martian Boogie," in 1977, they had recorded seven top 100 hits. Koda died in 2000 at 51 years. (Frank Pettis.)

Stevie Nicks was born Stephanie Nicks, in Phoenix in 1948. Raised in San Francisco, Nicks became a vocalist with the band Fritz and met Lindsey Buckingham in 1973. That year, they recorded an album, Buckingham-Nicks. In 1975, Nicks and Buckingham entered the world of rock legends when they became part of the reformulated British group Fleetwood Mac. This group had 25 top 100 hits by 1998. As part of Fleetwood Mac, Stevie Nicks was inducted into the Rock and Roll Hall of Fame in 1998. The group continues to perform, including Detroit, as recently as 2001, when they played Detroit's DTE Center. (John Steele)

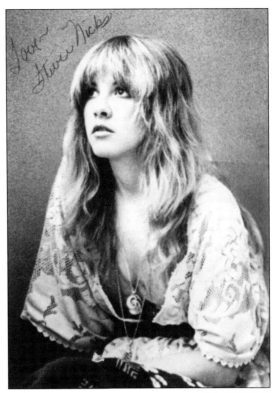

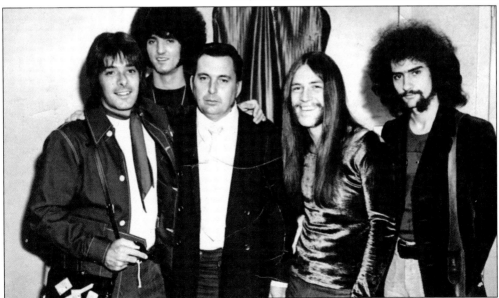

Grand Funk Railroad was formed in 1968 by former members of Terry Knight and the Pack. Mark Farner and Don Brewer had been with Terry Knight and the Pack. Mel Schacher, previously with Question Mark and the Mysterians, played bass and rounded out the group. In this 1968 photograph, coauthor and the group's Detroit promoter Bob Harris, is pictured with the group. Their first No. 1 hit, "We're an American Band," was released in 1973. Brewer and Schacher continue to perform as Grand Funk Railroad. Farner also continues to perform.

Benny Spears, of Benny and the Jets, was born in Ann Arbor in 1955. He first hit the stage in 1973, starting out with his greaser band that has toured the United States and Canada with many major rock bands. He is the son of Dr. Leo Spears, owner of several clubs in the Detroit area during the 1960s and 1970s. Leo also owned the famed Michigan Palace rock venue. Benny released three albums in the 1970s and currently plays over 250 gigs a year. (Frank Pettis.)

Leo, father of Benny, opened the 5,000-seat Michigan Palace as a rock venue in 1973. Kiss was the first band to play in this venue. The Michigan Palace gave stage to many major rock bands. Some suggest that Leo's financial success there caught the eye of a young Mike Ilitch, who later bought the nearby Fox Theatre, which in turn has led to the rebirth of the district, which includes the new Lions' and Tigers' stadiums. Leo died in 2002.

Emmylou Harris was born in Birmingham, Alabama, in 1947 and charted 51 country hits as a singer and guitarist before achieving success in pop rock. She formed her own band and recorded her first top 100 hit, "If I Could Only Win Your Love," in 1975. Her 1980 duet with Roy Orbison, "That Lovin' You Feelin' Again," hit the top 100 charts and was used in the movie *Roadie*, starring Meatloaf. Her last top 100 hit, "Mr. Sandman," was released on an album that included vocals by Dolly Parton and Linda Ronstadt. She played Detroit's State Theater as recently as December 2007. (Caroline Greyshock.)

Cheap Trick formed in the mid-1970s, in Rockford, Illinois. Rick Nielson, Tom Petersson, Robin Zander, and Bun E. Carlos had their first top 100 hit with "Surrender," released in 1978. In 1979, the group released "I Want You To Want Me." It stayed on the top 100 charts for 19 weeks. Their only No. 1 hit, "The Flame," was released in 1988. In July 2007, the band played Detroit's Motor City Casino stage. (Caroline Greyshock.)

Lynyrd Skynyrd was formed while Ronnie Van Zant, Gary Rossington, and Allen Collins were in junior high school in Jacksonville, Florida. Their first and biggest hit, "Sweet Home Alabama," was released in 1974. Van Zant and several members of the group were killed in a tragic plane crash in 1977. The band reformed under Van Zant's brother Johnny Van Zant. Pictured in this 1978 photograph, from back to front, are Gary Rossington, Billy Powell, Ed King, Custer, Leon Wilkeson, Randy Hall, and Johnny Van Zant. In 2002, Detroit's bad boy Kid Rock filled Detroit's Joe Louis Arena along with his special guest band, Lynyrd Skynyrd. (Michael Miller.)

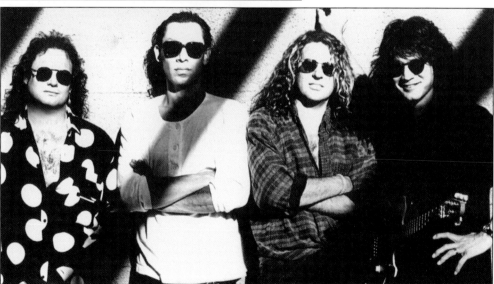

Van Halen is a hard-rock group that came together in Pasadena, California, in 1972. The members in this 1980's photo are (l-r) Michael Anthony, Alex Van Halen, Sammy Hagar, and Eddie Van Halen. Their first and only #1 hit, "Jump," was released in 1984. They continue to reunite and tour and played Detroit's Cobo Hall in 2007. (Bob Sebree)

Detroit's Ted Nugent, a heavy metal rock guitarist, was born in 1948. Leader of the Amboy Dukes and a member of the supergroup Damn Yankees, Nugent had his first top 100 hit, "Hey Baby," in 1976. "Cat Scratch Fever," released in 1977, is one of seven top 100 hits Nugent had up through 1980. Nugent still performs and is active in hunting and gun rights causes. Frank Pettis took this photograph at the Birmingham Paladium in 1970.

Kiss, a hard-rock group, came together in New York City in the early 1970s and has played Detroit more than any other big-name group. Bass guitarist Gene Simmons (1949), guitarist Paul Stanley (1950), lead guitarist Ace Frehley (1951), and drummer Peter Criss (1947) all shared vocals. Their first top 100 hit, "Kissin' Time," was released in 1974. "Beth," their biggest hit, went to No. 7 in 1976. Simmons was recently in the television reality shows, *Family Jewels* and Donald Trump's *Celebrity Apprentice*. (Jim Trojanowski.)

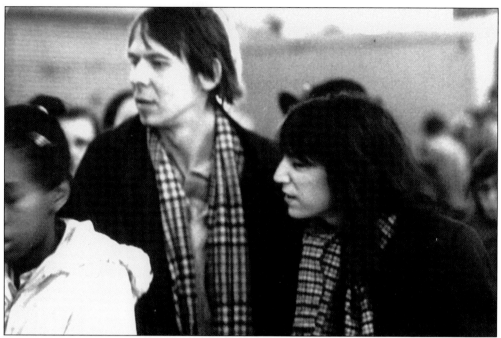

Patti Smith was born in Chicago in 1946 and raised in New Jersey. Her first top 100 hit, "Because the Night," co-written with Bruce Springsteen, was released in 1978. Her last hit, "Frederick," produced by Todd Rundgren, was released in 1979. In 1980, Smith married Detroit's Fred "Sonic" Smith of the MC5. They were together until Fred's death in 1994. In this 1981 photograph by Chris Foster, Patti and her husband, Fred, are looking at a display at Detroit's Eastern Market.

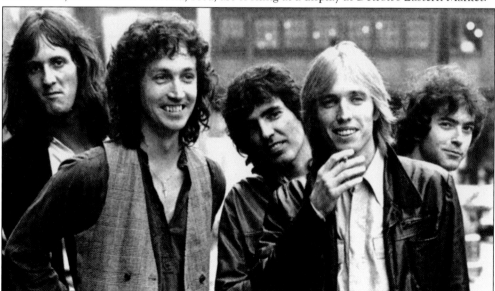

Tom Petty (second from right), born in Gainesville, Florida, in 1953, played guitar and sang lead vocals with Mike Campbell (guitar), Benmont Tench (keyboards), Ron Blair (bass), and Stan Lynch (drums). The Heartbreakers formed in Los Angeles in the mid-1970s. Petty worked with Roy Orbison as one of the Traveling Wilburys. Selected to play at the 2008 Super Bowl half-time show, Petty put together a tour that hit the Detroit-area Auburn Hills Palace.

Jimmy Buffett was born in Pascagoula, Mississippi, in 1946. Raised in Mobile, Alabama, he received a bachelor's degree in journalism from the University of Southern Mississippi. His first top 100 hit recording, "Come Monday," was released in 1974. "Margaritaville," his biggest hit, was released in 1977. His fans, almost as rabid as Deadheads, are called Parrotheads. They were out in full force when Buffet played in the Detroit suburb of Clarkson in 2006.

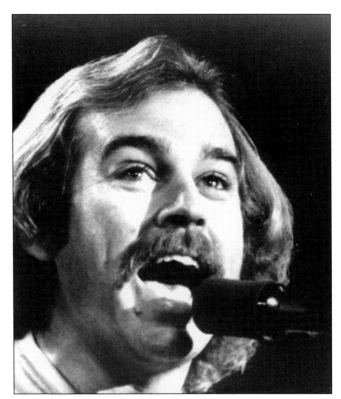

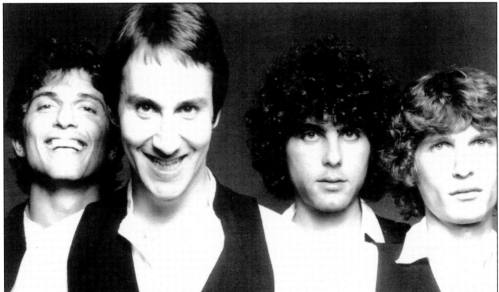

The Knack was formed in Los Angeles in 1978. Detroit's Douglas Fieger played rhythm guitar and sang lead vocals. In this 1979 photograph, from left to right, Bruce Gary (drums), Fieger, Prescott Niles (bass), and Berton Averre (guitar), make up the group. While in Detroit, Fieger fronted a band called Sky. The group's first top 100 hit, "My Sharona," released in 1978, went to No. 1. The group's album, Get the Knack, sold six million copies. (Photograph by Randee St. Nicholas, courtesy of Frank Pettis.)

The Olympia Stadium was Detroit's most important 1960s rock venue. The Beatles, the Beach Boys, Elvis, the Rolling Stones, the Monkees, Blind Faith, Cream, and every other big-name act played the "Old Red Barn." Built in 1927, it seated 16,000. In 1934, a promising amateur boxer named Joe Louis won his Golden Glove competition there, by barely beating Stanley Evans. The Red Wings won four Stanley Cups there in the late 1940s and 1950s. Politics, and the City of Detroit's desire to move the barn's tenants to the newly built Joe Louis Arena, led to Olympia Stadium's demise. Because the barn was owned by the City of Detroit, this grand venue did not have a chance. It was demolished in 1986 amid public uproar. In this photograph, the marquee shows the Beach Boys about to play the Old Red Barn. (The Burton Collection, Detroit Public Library.)

Madonna, born Madonna Louise Ciccone, in Bay City, Michigan, in 1958, blasted out of Michigan to become a rock queen. She performed as the drummer with the Breakfast Club pop-dance group in 1979. In 1980, she formed her own group, Emmy. Her first top 100 hit, "Like a Virgin," was released in 1984. She is the transition from the 1970s to the decades beyond. Madonna has recorded 49 top 100 hits. Of these, 12 were No. 1 hits. *Billboard* considers Madonna the No. 1 female vocalist in the entire rock era. In 2008, she was inducted into the Rock and Roll Hall of Fame. This legend and Michigan neighbors, Eminem, Kid Rock, 50 Cent, and a bunch of young talent coming up, suggest that Michigan's rock-and-roll future is as bright as its rock-and-roll past. (Herb Ritts.)

BIBLIOGRAPHY

Bond, Marilyn, and S. R. Boland. *The Birth of the Detroit Sound: 1940–1964.* Chicago, IL: Arcadia Publishing, 2002.

Carson, David A. *Grit, Noise, and Revolution: The Birth of Detroit Rock 'n' Roll.* Ann Arbor: University of Michigan Press, 2006.

Gordy, Berry. *To Be Loved.* New York: Warner Books, 1994.

Heatley, Michael, ed. *The Definitive Illustrated Encyclopedia of Rock.* Fulham, London: Flame Tree Publishing, 2006.

Partridge, Marianne, ed. *The Motown Album.* New York: St. Martin's Press, 1990.

Sullivan, Robert, ed. *Rock and Roll at 50.* New York: Life Books, 2002.

Taraborrelli, Randy. *Motown: Hot Wax, City Cool and Solid Gold.* Garden City, NY: Doubleday and Company, 1986.

Whitburn, Joel. *Top Pop Singles: 1955–2002.* Menomonee Falls, WI: Record Research, 2003.

INDEX

DISCOVER THOUSANDS OF LOCAL HISTORY BOOKS
FEATURING MILLIONS OF VINTAGE IMAGES

Arcadia Publishing, the leading local history publisher in the United States, is committed to making history accessible and meaningful through publishing books that celebrate and preserve the heritage of America's people and places.

Find more books like this at
www.arcadiapublishing.com

Search for your hometown history, your old stomping grounds, and even your favorite sports team.